R. Luke DuBois
—Now

R. Luke DuBois
—Now

Matthew McLendon

Anne Collins Goodyear

Dan Cameron

Matthew Ritchie

THE JOHN & MABLE RINGLING
MUSEUM OF ART

STATE ART MUSEUM OF FLORIDA | FLORIDA STATE UNIVERSITY

First published in 2014 by
Scala Arts Publishers, Inc.
141 Wooster Street, Suite 4D
New York, NY 10012

Scala Arts & Heritage Publishers Ltd
21 Queen Anne's Gate
London SW1H 9BU
www.scalapublishers.com

In association with The John and
Mable Ringling Museum of Art
www.ringling.org

Exhibition dates January 31 – May 4, 2014

ISBN: 978-1-85759-877-3

Project editor: Mariah Keller
Designed by Benjamin Shaykin
Typeset in Lyon, Atlas Grotesk, and Pitch
Printed in China

10 9 8 7 6 5 4 3 2 1

FRONTISPIECE: Detail, *Sergey Brin and
Larry Page*, 2013. National Portrait Gallery,
Smithsonian Institution; supported by a grant
from the Donald W. Reynolds Foundation and
by the Marc Pachter Commissioning Fund.

PHOTO CREDITS: All photographs are
courtesy of the artist and bitforms gallery,
New York. Page 35 and 102–03: *Hindsight
Is Always 20/20*, 2008 (installation,
National Constitution Center, Philadelphia),
photograph by Carol Feeley. Pages 95 and
108–09: *Hindsight Is Always 20/20*, 2008
(installation, DUMBO, Brooklyn, 2012),
photographs by John Berens. Page 115:
Hindsight Is Always 20/20, 2008 (installation,
The Weisman Art Museum, University of
Minnesota, Twin Cities, 2008), photograph by
Rik Sferra.
All photographs of *The Marigny Parade* are
by Scott Saltzman.

Contents

Director's Foreword 6
Steven High

Acknowledgments 7
Matthew McLendon

Introduction—The Apophenic Cowboy 9
Matthew Ritchie

Now—The Temporality of Data 12
Matthew McLendon

Visualization—The Art of R. Luke DuBois 22
Anne Collins Goodyear

Unfashionably Early for the Art World 32
Dan Cameron

Catalogue 38
Liner Notes by R. Luke DuBois

Select Bibliography 141

Contributors 143

Director's Foreword

R. Luke DuBois—Now marks the opening of the fourth year of the Art of Our Time initiative at The Ringling. The initiative seeks to create dialogues between the visual and performing arts in a contemporary space in which genre is increasingly, if not wholly, irrelevant. R. Luke DuBois is the perfect artist to embody that vision. DuBois is visual artist, composer, collaborator, filmmaker, computer programmer, and scientist simultaneously.

Over the last decade, he has produced a prodigious body of work. Typically classed as a "new media" artist, this survey of his work demonstrates that DuBois operates at the intersections of the visual, the performative, and the time-based. The mining and manipulation of data into art as well as investigations of temporality, two dominant themes explored by DuBois, are represented by, among others, *Hindsight Is Always 20/20* (2008), *A More Perfect Union* (2010-11), *Fashionably Late for the Relationship* (2008), and *Academy* (2006), all of which have received national and international critical attention. DuBois's wide-ranging interest in popular culture forms the basis for works such as the video pieces *Pop Icon: Britney* (2010) and *Play* (2006), and the sound work *Billboard* (2006). We are particularly pleased to present the premiere of a new video work created by the artist while in residence at The Ringling. Drawing upon the Ringling legacy while connecting to contemporary circus performance, DuBois's newest video highlights one of the greatest ongoing examples of the collective performance experience.

We are proud to present the first museum survey of R. Luke DuBois at The Ringling. Special recognition goes to Matthew McLendon for his curatorial leadership on this project. We are indebted to Luke, bitforms gallery, his collectors, and his collaborators for working with us. We also thank our local circus community for collaborating with Luke and the Hermitage Artist Retreat for supporting Luke's residency here. Finally, thanks go to The Ringling's membership whose support underwrites new curatorial projects, to the Amicus Foundation and Gulf Coast Community Foundation, and to Florida State University.

Steven High
Executive Director
The John and Mable Ringling Museum of Art

Acknowledgments

I met R. Luke DuBois, by chance, at a dinner party in early 2012. Luke was in town collaborating with the musician and performance artist Bora Yoon as part of ongoing programming for the Hermitage Artist Retreat, Manasota Key. It was my great fortune to sit across from Luke that night. I, like so many others, was astounded not only by his intellectual and creative capacities but also by how completely affable and approachable he is. I knew immediately that I wanted to work with him. In the almost two years that it has taken to bring this project to fruition, Luke has continued to be the friendly, generous, and astonishingly creative man I met that night. He has been an absolute delight to work with, and I am humbled by the fact that he has trusted me to collaborate with him in creating his first one-person exhibition.

Many thanks also go to the contributors to this catalogue, Matthew Ritchie, Anne Collins Goodyear, and Dan Cameron. Each has provided insights into Luke's work that will set the foundation for future scholarship surrounding his oeuvre. They have also been incredibly generous, understanding, and, most important, quick in delivering their manuscripts under a punishingly short deadline. Their words greatly augment this project. Three important artists in their own rights—Bora Yoon, Todd Reynolds, and Lesley Flanigan—as well as the Lostwax multimedia dance company, were also a part of this exhibition through collaborative performances with Luke. Each contributed meaningful performances that helped the audience of the exhibition come to a fuller understanding of Luke's practice.

In putting together a survey of any contemporary artist, a curator is reliant on those whose job it is to foster the career of the artist in the wider world: the gallery. Again, I could not ask to work with more agreeable and helpful people than Steven Sacks and Laura Blereau of bitforms gallery, New York. At every turn, they were available to answer my questions and provide the necessary resources for making this project a reality. I owe them and their entire team an enormous debt of thanks. I am also grateful to the lenders to the exhibition, including John and Amy Phelan.

My colleagues at The John and Mable Ringling Museum of Art have offered support at every stage. My conversations with Dr. Virginia Brilliant always serve to challenge and inform my views of the very nature of our work. Chris Jones read the initial draft of my essay and provided important feedback that helped make it more cogent. Deborah Walk and Jennifer Lemmer-Posey gave much assistance in helping to research our rich circus history for the foundation of the new work premiered

in the exhibition. Aaron Muhl was also instrumental in assisting with the filming. Peg Thornton and Gussie Haeffner were instrumental in handling logistics for the visiting artists and filming. Françoise Hack, Gabriela Gil, Jessie Christian, and Heidi Taylor of our Collections and Registration Department are the unsung heroines of every exhibition at The Ringling, making sure that all of the wheels keep turning. The exhibition would quite literally not be possible without the immense talents and dedication of Matthew Lynn, Carolyn Hannan, Norman Cornwell, Emily Meyer, Zach Hudson, and Donn Roll of the Preparation Department. Matthew and Carolyn in particular take my simple ideas and make them into realities I could not imagine. Pam Fendt and the entire Marketing Department ensured the word spread far and wide about this important artist, and Pam, as always, answered my many design and printing questions ensuring that this book is worthy of the work it contains. I am always grateful for the profound support I am afforded from our Executive Director, Steven High; Peter Weishar, Dean of the College of Visual Arts, Theater, and Dance, Florida State University; and the Board of Directors of The Ringling. Finally, I am most thankful for my colleague Dwight Currie, Associate Director of Collections and Programming. In the four years that I have been at The Ringling, Dwight has been not only a collaborator in the establishment of the Art of Our Time initiative—The Ringling's ongoing program of visual and performing contemporary arts—but he also has been a mentor and dear friend. I marvel at his talents, and my own work has been greatly enriched and expanded by his insights. Would that everyone was as lucky to have a colleague with whom they are so completely simpatico.

I would also like to thank my colleagues Bruce Rodgers and Patricia Caswell at the Hermitage Artist Retreat who were instrumental in my meeting Luke and who later extended a residency to him. I am also most appreciative to my colleague, Dr. Joyce Tsai, who provided theoretical insights in the early days of this project and reminded me of the importance of Merleau-Ponty.

I owe a special debt of gratitude to Pedro Reis and Dolly Jacobs, Co-Founders of Circus Sarasota. Their incredible generosity of time, talent, and knowledge enabled the creation of a new work of art celebrating the circus and its long relationship with The Ringling and the community.

I want to thank the team of artists and editors at Scala Art Publishers, Inc., who have exceeded my expectations in every way in bringing this catalogue to fruition. Jennifer Norman and Oliver Craske take such great care of me and bring together the most brilliant people with whom to work. Mariah Keller was a most sensitive and considerate editor and project manager. I can certainly say that my essay greatly benefited from her suggestions. Ben Shaykin was so evidently excited by and committed to this project from the beginning. His beautiful design for the catalogue honors the work and the artist. Tim Clarke and Claudia Varosio as always made sure production deadlines were met and all arrived on time and without stress. Thank you all.

As with everything that I do, my dear friend and mentor, E. Luanne McKinnon, provides me support, encouragement, and laser-accurate insight. She read and provided an immensely important critique of my essay in its initial form. Finally, I thank my family who have supported me and continue to do so at every turn.

Matthew McLendon, PhD
Curator of Modern and Contemporary Art
The John and Mable Ringling Museum of Art

Introduction—The Apophenic Cowboy

As Robert Smithson often noted, "you don't have to have cows to be a cowboy."

While Carl Jung invented the term "synchronicity" for the "simultaneous occurrence of two meaningful but not causally connected events," Peter Brugger has countered by defining "apophenia" as the "unmotivated seeing of connections" accompanied by a "specific experience of an abnormal meaningfulness." By 1995, the rapid emergence of the World Wide Web and consumer-grade computational spaces quickly expanded the definitions of both the field of cultural production and human connectivity. We are now saturated with more images and words in a single day than an average person would have seen in their entire lifetime one hundred years ago. A glance at the web confirms that the computational space that conveys this has no meaningful aesthetic; its collective appearance is simply the haphazard result of legacy coding and commercial guesswork, and we are unable to easily discern whether the data contained inside the space is meaningful or not. It may be wide-ranging but it is not informationally deep. In addition, in comparison to the information capacity of the universe (or nature), anything communicated through the pipe of digital media is highly compressed and often degraded—what is often described as "image saturation" might be more accurately understood as the mechanical repetition of a range of highly compressed visual phenomena specifically designed to attract and retain a narrow spectrum of human attention.

It is a space of sharing but not necessarily a generous, or even reciprocal space. Apophenia is the neurological glue of conspiracy pages, online horoscopes, and gambling sites. They are the wide prairies of digital country, where bovine human attention is easily corralled and preyed upon.

This is where the apophenic cowboy rides.

If he did not exist, R. Luke DuBois would be invented by the systems he shares, plays with, and repurposes. Since 2000, he has worked with the San Francisco-based software company Cycling'74, creators of the programming environments Max/MSP and Jitter, the project with which he is most involved. Jitter allows a Max programmer to work with anything that can be entered into computational space. Its uses potentially extend to all areas of the human project that can be mediated by computational space (and to date, no human activity has been discovered that cannot be mediated by computational space), and it is widely used by composers, performers and artists to create innovative recordings, performances, and installations. As an artist, a writer

of Max and an ardent and genial collaborator, Luke DuBois expands both the map and territory, helping dude ranchers like myself ride the computational range.

As a musician, much of DuBois's own work integrates real-time performer-computer interaction with similar algorithmic methodologies from other fields, most notably formal grammars such as "L" or Lindenmayer systems, which are also used in the generation of parameter-based artificial life. The American composers Max Mathews and Earle Brown pioneered that approach in music in quite different ways. While Matthews paved the way for electronic music with HAL's eerie performance of "Daisy Bell" in Kubrick's *2001*, Brown pioneered the concept of the "open score," a work composed in fixed modules but with the order left free to be chosen by the conductor during performance. In both cases, the concept of the human gesture is contrasted with a highly ordered system. Building on those precedents, DuBois's musical/informational practice is epitomized by his project *Hard Data*, which began as an interactive website and grew into a string quartet in six movements. Taking economic, social, casualty, political, and cultural statistics from Iraq and the United States over the course of the war in Iraq, he created an open-source "information score." Just as in music and life, the long imagined dream of combining the fluency of the human gesture with the certainty of the machine is being realized in parameter-based "organisms" that can change within predefined limits. In 1997, William Gibson, surely the H.G. Wells of our time, imagined a holographic composite called *Rei Toei* that was built from the collected "desires" or information of the Internet. In 1999 Philippe Parreno and Pierre Huyghe acquired the copyright for a cartoon figure called "Annlee," and they used her in their collaborative project *Ghost without a Shell*. By 2000, the Ananova news service featured a computer-simulated newscaster programmed to read newscasts. In 2007 the vocaloid Hatsune Miku was "released." A real singing synthesizer application with a humanoid

persona built by Crypton FutureMedia, the holographic singer will be styled by Louis Vuitton for an upcoming 'Vocaloid opera' entitled *The End*. It will feature no human singers. Closing the circle, DuBois's 2010 *Pop Icon: Britney* takes all of Britney Spears's videos and subjects them to a computational process that locks her eyes in place, creating a constantly shifting halo around her face. As DuBois notes, "Spears is the first pop star to exist entirely in the age of AutoTune and Photoshop. All of her vocals are digitally corrected and she lip-syncs her live performances; as a result, there is precious little phonographic record of Britney actually singing, merely the digitized re-synthesis of her voice, perfectly in tune."

Max's slogan is "connect anything." That is without question the motto of a future arriving early. The central theme of Gibson's *Pattern Recognition* (2003) involves the natural human propensity to search for meaning with the constant risk of apophenia. The novel features Nora Volkova, an artist responsible for distributing a series of anonymous, artistic film clips via the Internet. Followers of the seemingly random clips seek connections and meaningfulness in them but are revealed to be victims of apophenia as the clips are just edited surveillance camera footage. Here too, a convergence is already under way. DuBois's *Acceptance* (2012) takes the acceptance speeches given by President Barack Obama and Governor Mitt Romney in 2012 and subjects them to a never-ending editing process based on their language. The piece synchronizes the two candidates' language, so that they deliver each other's speeches in true algorithmic synchronicity.

On the computational event horizon, the gap between synchronicity and apophenia is collapsing. Herman Hesse imagined his *Glass Bead Game* as an abstract synthesis of all arts and sciences that would take place many centuries into the future. In his game, players proceeded by making deep connections between seemingly unrelated topics, and playing the game required years of study of music, mathematics, and cultural history. Our games

proceed through vast, unseen programs like PRISM and Boundless Informant. We might prefer to consider ourselves operating in a regime of ephemerality that Paul Chan calls "Kairotic" time, haunted by the idle and sadistic dreams of the preceding symbolic eras but insisting on a fragility of discourse that renders moral outrage ontologically impotent, a column of smoke, circling in an entropic spiral. But the growing reliance of contemporary art culture on computational space, the stealthy but steady emergence of an essentially eidetic or algorithmic culture that essentially reverses Milman Parry's definition of eternal oral formulas—"groups of words regularly employed under the same metrical conditions to express a given essential idea" that so inspired Marshall McLuhan—makes the review of underlying concepts of computational art all the more urgent.

Perhaps we are only at the beginning of Hesse's game but we have certainly entered the time and space predicted by what we still prefer to call "science fiction" (no matter how accurately it now describes contemporary life). It is in this world—where robot soldiers fight wars for us, giant mechanical brains read our minds, and computer-generated bands perform songs—that artists like Luke DuBois range freely, making works that cannot be classified in any single genre, save their own.

"Just beyond the mountain lies a city
And I hear it calling me
Saddle up and ride, you lonesome cowboy
Here is where you'll find your destiny."
—Lonesome Cowboy
Tepper & Bennett, 1957

Matthew Ritchie
Artist

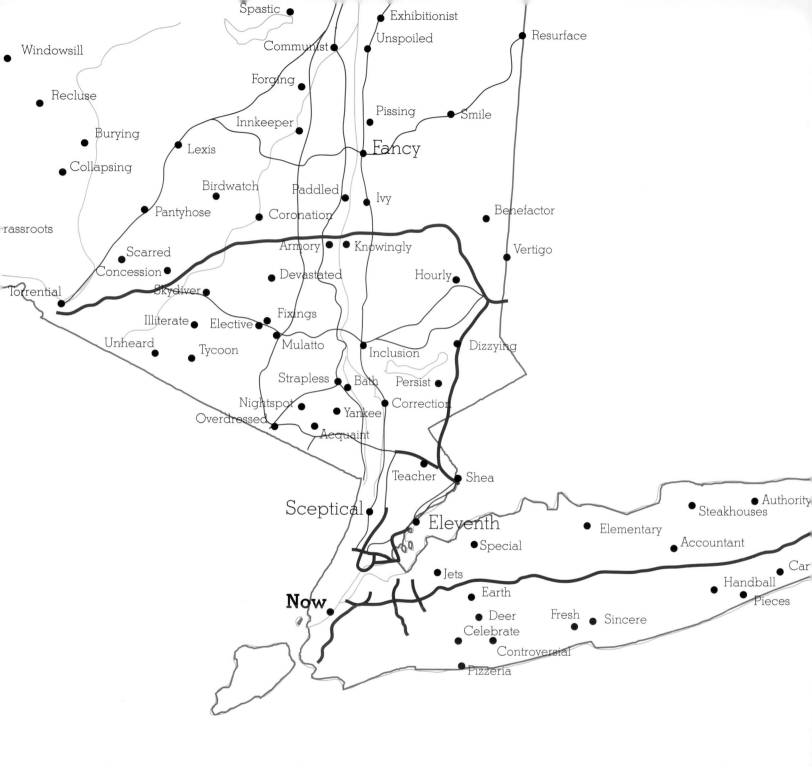

FIG. 1. Detail, *A More Perfect Union: New York*, 2010–11.

R. Luke Dubois — Now

Now—
The Temporality of Data

Matthew McLendon

"Temporality is a theme in much of my current work, and riffs to a certain extent off of the idea that we are running out of time." —R. Luke DuBois[1]

"Time presupposes a view of time." —Maurice Merleau-Ponty

The Mapping of Data

When looking at R. Luke DuBois's map of the United States of America for his project, *A More Perfect Union* (2010–11), it takes a moment to recognize what is off, what is not quite right. You vaguely know where Atlanta should be in the state of Georgia, but it is not there. Instead you see the word, "God." Looking for Houston, you find "Rich," and where the epicenter of American commerce and culture should be found, you read "Now" in place of New York City (FIG. 1). Yet, "Now" tells you most everything you need to know about New York City—the "city that never sleeps" because so much is happening now! "I'm really an actor, but I'm waiting tables now." "Now is the winter of our discontent." "Now playing."

"Now showing." "Now on Sale." "M4M, Now." There really is no other place that is so insistently "now."

DuBois's census of America's lonely hearts was born out of his interest in creating a data-driven work of art like *Hindsight Is Always 20/20,* a visual compendium of presidential State of the Union addresses that was commissioned for the 2008 Democratic National Convention.[2] In the lead-up to the U.S. census, which would commence in 2010, his decision was certainly timely—of the "now." In an interview with Erika Rydberg for NPR's *All Things Considered* (2011), DuBois related, "The U.S. census is a pretty interesting and very flawed process, so I wanted to respond with something that was equally flawed. So *Perfect Union* takes the U.S. census as a departure point and changes the terms of the game by looking at prosaic self-identity (how we describe ourselves in writing), instead of mundane socio-economic facts."[3]

After breaking up with his girlfriend, DuBois was encouraged to try online dating—a common practice for many thirty-somethings who had lived entirely in the computer age, from their first programming lessons in LOGO (remember the turtle) during elementary school to being sent off to grad school with their very first laptops.[4] By the mid-2000s, online dating had gone from being the slightly more embarrassing new cousin of the print personal ads (as it was popularly portrayed in the mid-1990s) to an increasingly accepted form of social interaction among both busy professionals who had little time or appetite for the singles scene and those who were isolated, either geographically or through minutely nuanced sexual desire. The Pew Research Center reported in 2006 that 31 percent of all American adults knew someone who had used online dating.[5] And so, DuBois entered the online dating phenomenon; however, instead of joining just one or two sites, he created profiles for twenty-one different sites, and used more than nineteen million individual dating profiles (which he had downloaded over a six-week period) to create a new kind of American census.

Taking advantage of thirty-day-free trials, DuBois joined not only well-known sites, such as match.com, eharmony, christianmingle, and chemistry.com, but also niche sites like alt.com and collarme.com. He created profiles as both straight and gay (where allowed) men and women. Using special software on ten computers, DuBois downloaded the matches in every zip code of the United States. He then used software to tease out significant keywords (excluding pronouns, particles, etc.), score the number of times that each word was used in a particular city, and assigned those words to a city, using it only once in the process. After scanning an old Rand McNally trucker road atlas into digital files, he then redrew the lines of the roads and placed city dots (now keywords) by hand.

The state and city maps were only one half of the project. DuBois also created a series of choropleth maps—a method of cartography in which areas are shaded depending on statistical analysis (population density and per capita income are two common uses for the choropleth map). In a riff on red/blue state politics, he assigned those colors not to political affiliation, but rather to gender—red for female, blue for male. Basing the analysis and format on congressional districts, rather than political information, the infographics—visualizations of data or data sets (a common example would be a subway map)—show the proportions of men and women who self-describe as "lonely," "shy," "sexy," "bored," "crazy," "funny," and "kinky," to name just a few. (Take note: The kinkiest women are in West Virginia, while kinky men prefer the Southwest [FIG. 2].)

The process is, like the census it parodies, inherently flawed. DuBois admits, "The great thing is that computers allow us to prepare very accurate displays of large data sets without too much work. The problematic thing is that they reduce our landscape of knowledge to pie charts. Even more problematic is that you can lie with statistics pretty easily."[6] However, in this age of boundless, undigested information, the flaws are

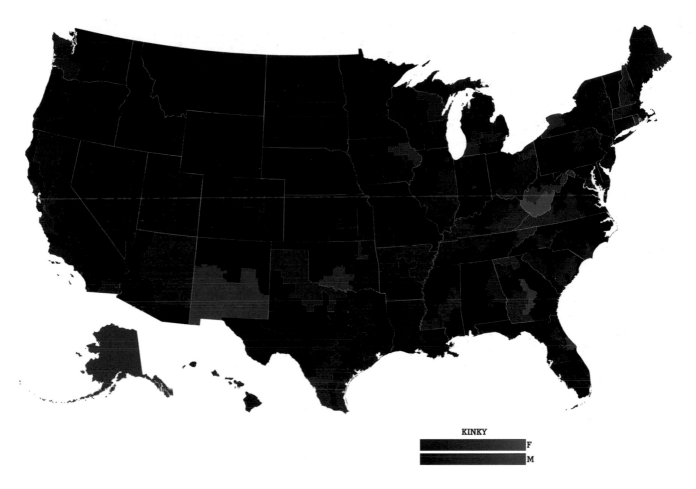

FIG. 2. *A More Perfect Union: Kinky,* 2010–11.

important reminders that we rarely look beneath what is packaged in quasi-scientific visual rhetoric. As Joshua Decter mused in his *Artforum* review of the work: "We may also want to consider the ethical side of this since, as a software author, DuBois is in a privileged position to both shape and redeploy massive amounts of human information, which implies a significant amount of control, even if the objective is to produce a mode of service-based artistic practice."[7] When considering these admonitions, DuBois, as the "man behind the curtain," then elucidates the obscured puppetry of our contemporary sociopolitical data analysis, which always purports to be "objective."

The condensation and translation of large amounts of data into readily accessible visual representations is certainly the most obvious aspect of *A More Perfect Union,* and it has been the focus of discussion surrounding the project from its first display. It represents an important sub-section of DuBois's polymathic oeuvre—infographics that include works like *Hindsight Is Always 20/20,* as well as less obvious examples, such as the generative work, *Missed Connections* (2012), which analyzes and translates

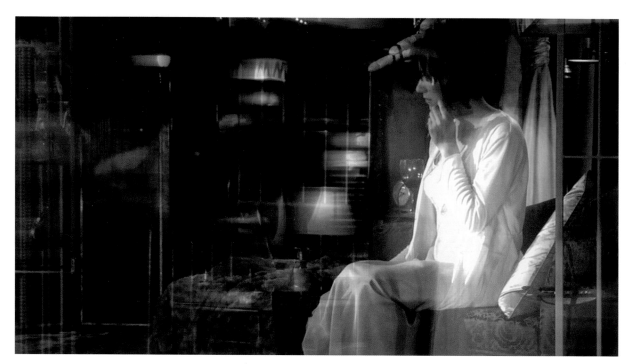

FIG. 3. Video still, *Fashionably Late for the Relationship*, 2007–08.

data mined from Craigslist in real time, creating word-based visuals in an attempt to bring together the authors of Missed Connections posts to the popular website. I would argue, however, that the relationship of *A More Perfect Union* to notions of time proves a more subtle and nuanced overarching exploration that binds together many aspects of DuBois's disparate output.

New York City is "Now" in DuBois's alternate United States, just as the data mined from the nineteen million plus online dating profiles presents a "profile" of any given person or set of persons at that moment, the now. Perhaps the greatest illusion of any statistical analysis is that it presents itself as rooted in a moment in time that will eventually be given the imprimatur of "fact" because it is tied to our collective and largely uncritical trust in the "historical." Accordingly, we are led to believe that more people in New York City are interested in the "Now," than are people in Atlanta, who are preoccupied with

"God," or in Miami where being "Latino" is consuming their sunny days. In gathering the keywords for every zip code in the country, DuBois employs the inherently malleable, or that which is most temporal—how we describe ourselves at any given moment—and concretizes it, fixing it in time and space, or at least presenting the illusion of doing such. Therefore the "now" of New York references the present but also the past (2010 when the data was collected) and the future (the exhibition of this work and any analysis of it). More than any critique of the essentialized red/blue state divide or our social voyeurism that compels our interest in which parts of the country are most shy or kinky, the critique of the relationship between time and statistical analysis that purports to be representative of the "now" is by far the more potent discourse. Is the now of 2010 still the now of 2013? Certainly not. But are the two linked? In his exploration of the concept of "temporality," Maurice

Merleau-Ponty concluded that "a preserved fragment of the lived-through past can be at the most no more than an occasion for thinking of the past."[8]

Temporality Condensed

The exploration of temporality is even more evident in DuBois's most challenging project to date: the film *Fashionably Late for the Relationship* (2007–08). A collaboration with the performance artist Lián Amaris Sifuentes, the film chronicles the performance of a young woman preparing for a date in her boudoir (FIG. 3). The setting, however, is more of a suggestion—a few pieces of self-consciously traditional and "feminine" furniture placed on an ornate rug and shielded from the sky by a twenty-foot-square canopy that is open on all sides. It rests in the middle of a traffic island in New York's Union Square, and it takes the woman, Sifuentes, seventy-two hours to prepare for her date.[9]

On the weekend following July 4, 2007—always one of the busiest weekends in the city and in the middle of a heat wave—Sifuentes, DuBois, and a production team of about thirty people descended on Union Square. The performance and filming began simultaneously at midnight on Friday, July 7, and continued into Saturday with Sifuentes "sleeping" on her chaise. In the film, she awakens sometime around 5 a.m. and begins preparations

The work of art, from its conception and existence in the long genealogy of performance art, is bipartite, with both expressions being "complementary and symbiotic." The original, or "ur-text," so to speak, is the seventy-two-hour performance by Sifuentes, and DuBois takes great pains to underscore that Sifuentes was solely responsible for the live aspect of the work. The live performance is a meditation on feminine rituals of beauty and dating, as well as a continuation of the critique of the gaze in all of its forms. The performance lives on and is reinterpreted by DuBois in a seventy-two-minute film complete with a musical score composed by DuBois and his frequent collaborator, the violinist Todd Reynolds.[10]

for her date, which is scheduled to occur some sixty-five hours later. She eats, drinks wine, smokes, and tries on a few dresses, all of which is perfectly normal behavior when preparing for a night out. However, she engages in those activities in a painfully slow manner—with meticulous deliberation (think of Martha Rosler's *Semiotics of the Kitchen* from 1975)—while DuBois and his film crew record her with three or four high-definition cameras. Later, software that both accelerated and blended the footage was used to manipulate the film to sixty times its original speed. Therefore, a task that actually took one minute is seen as taking one second—an hour then becomes a minute, seventy-two hours of performance becomes seventy-two minutes of film.

The visual effect of this manipulation is at times jarring, such as the moment at which one sees the hands of the clock—which are conspicuously placed like a Greek chorus commenting on the passage of time—racing around the clock face. More often, however, it is haunting, even poetic. The rhythmic pulse of the street lights turning from red to green and the ensuing rush of traffic becomes the metronomic stand-in for the rise and fall of Sifuentes's chest as she sleeps—a detail that is largely lost (or at least interrupted and syncopated) as it is too quick for the human eye when each frame of video becomes the average of sixty frames.

DuBois, who holds a Ph.D. in music composition (he composes the music that accompanies his visual works), compared the editing of the film to the creation of a "concerto between Lián and the city around her. When she is on the set performing her actions, the cameras focus on her; the rest of the time they do their best to absorb the environment flying by."[11] For DuBois, the primary theme of the film is the exploration of obsession. At times in the editing, he layered video from multiple camera views, or even from slightly different moments in time, to recreate the "obsessed perspective." DuBois isolated an eight-part "taxonomy of traits or attributes that can be ascribed to the obsessed situation," and he

then based all of his editing decisions on Heterotopia, Panopticon, Time-machine, Marionette, Guardian, Labyrinth, Hyperthymesia, and Possession.[12]

"Temporality is a theme in much of my current work, and riffs to a certain extent off of the idea that we are running out of time. The hyper-mediated experiences of our accelerated culture have a detrimental effect on our ability to truly linger; obsession on a subject, therefore, is always at the *expense* of the un-obsessed."[13] It seems mildly ironic, then, that in his deep exploration of "obsessive time" DuBois would speed up a medium that is (perhaps more than any other) associated with the rapidity of contemporary life. Yet, the editing possibilities of high-definition video—the layering of multiple perspectives—are, of course, the ideal medium through which to meditate on the scopophilia (the pleasure of looking) of the obsessive.[14] The temporality elucidated by *Fashionably Late for the Relationship* is beyond the merely psychological phenomenon of obsession. Through DuBois's manipulation of the coordinates of "time" (the speeding up and condensation of the frames) and spatial perspective (the overlapping of points-of-view), the film unconsciously unfolds following the paradigm of time put forth by Merleau-Ponty: "The past, therefore, is not past, nor the future, future. It exists only when a subjectivity is there to disrupt the plenitude of being in itself."[15]

In his critique of Henri Bergson's proposal of a unification of a passage of time in which we pass from past to present to future in imperceptible transitions that preserve the isolation of each temporal coordinate, Merleau-Ponty argued that while there is continuity, "instant C and instant D, however near they are together, are not indistinguishable, for if they were there would be no time; what happens is that they run into each other and C becomes D because C has never been anything but the anticipation of D as present, and of its own lapse into the past."[16] DuBois's creation, as it manipulates our perception of recorded time, is reliant on the necessity of the "subjectivity" necessary to rupture the "plenitude of being in itself."[17] The first subjectivity is DuBois himself as he then manipulates and edits his footage; the second is that of the viewer as he or she becomes the adjudicator of the display of temporal expansion, deciding at each moment whether what is being viewed is a past, present, or future moment. Over the course of the seventy-two-minute film, the attentive viewer becomes aware of not only the relentless march of time as signified by the clock on the nightstand, but also that he or she is subsumed in Merleau-Ponty's notion of a unification of time in which the past, present, and future do not exist in isolation but rather take part in a dynamic race toward and away from each other: "It is not the past that pushes the present, nor the present that pushes the future, into being, the future is not prepared behind the observer, it is a brooding presence moving to meet him, like a storm on a horizon."[18]

However, for Merleau-Ponty, consciousness is never absent, and it is consciousness that allows us to project our artificial construct of time. As DuBois layers differing camera angles, the viewer sees Sifuentes seated, drinking a glass of wine, and languorously smoking a cigarette while images from different angles—a profile view, a long shot, traffic racing by—are superimposed. She seems not to be smoking, and then she is smoking again. Then she is on the phone. To the left of the screen she stands, pacing back and forth, while on the right side of the screen she simultaneously sits, still talking on the phone. Where is her past, present, and future within the temporal fluidity created by DuBois? We the viewers are constantly asked to renegotiate our relationship to Sifuentes's "moment" in the midst of the destabilized scopophilic state of the obsessed mind before she, attired in the party pink halter dress of the obsessive's desire, rises and slowly, even in the compressed time of the film, walks out of her boudoir, her wrap trailing behind her like the scent of soft perfume. She then lifts her arm to hail a taxi, both reaffirming the narrative and bringing the viewer solidly into the midst of a specific moment—the now.

FIG. 4. *Pop Icon: Britney*, 2010.

Fashionably Late for the Relationship is only one of several works in which DuBois uses the extreme condensation of time to comment on social relationships and to problematize our traditional notions of time within our ever-expanding digital age. In *Pop Icon: Britney* (2010), he again uses proprietary software to call attention, not to individual obsession within the privacy of the obsessive's mind, but rather to collective obsession with celebrity within the public sphere to which we have seemingly unfettered and immediate access via the digital world (FIG. 4). Using all extant video footage of Britney Spears, he subjected the imagery to a "computational process that locks her eyes in place, allowing the video frame to pan around Britney in the frame, keeping her in a fixed position akin to an Orthodox icon. Her image is stabilized and blurred, creating a constantly shifting halo or aura around her face, reflecting back our gaze."[19] He then isolated her voice from her singles by stripping the vocals from the accompanying music and filtered them through the reverberation of San Vitale Basilica in Ravenna, Italy.[20] The resultant artwork is a 21½-inch LCD monitor encased in a gilded Baroque frame that constantly radiates images of Britney accompanied by an almost familiar, though wholly abstract, musical score.

In seeing "all" of Britney Spears through DuBois's characteristic temporal fluidity, the critique is not simply the elevation of celebrity to quasi-religious status but more so the notion of celebrity within time. Long gone is the now seemingly quaint and naïve belief in our fifteen minutes of fame as prophesized by the hierophant of popular culture, Andy Warhol. Through the infinitely expanding digital/virtual universe, today's celebrity, no matter how minor, is promised an eternal palimpsest of reference, both visual and verbal. To paraphrase Walter Benjamin, Spears is the celebrity in the age of digital

reproduction. As we confront the extant imagery of Spears in this condensed form, we come to understand that the concepts of her past, present, and future have no currency within the virtual world, where there is only ever the omnipresent now.

Finally, in his 2006 video work *Academy*, DuBois seamlessly blends his experimentations in infographics (though this time through video, not static print) and temporal condensation. According to DuBois, *Academy* "allows us to explore the temporal, formal, and aesthetic progression of the first seventy-five years of the Academy Awards by taking each film and compressing sound and picture into a single minute. In addition, the piece attempts to interrogate issues of film canon by presenting the Best Picture winners in chronological order in a massively condensed timeframe."[21] By viewing the Best Picture award winners in this manner, a number of important aspects of cinematographic history become easily legible. For instance, at the beginning of *Academy*, which features movies from the 1930s and '40s, the individual films are largely discernible because the shot lengths are longer. Overtime, the shot lengths became shorter, so that by the time of a movie like *Chicago* (2002), the films are largely an indecipherable blur. Radical changes in the blocking or movement of the actors is also apparent. DuBois observes, "When Humphrey Bogart is delivering his lines in *Casablanca* (1942), he is still, so in *Academy* you can make him out. By the time of *On the Waterfront* (1954), blocking has changed and actors deliver their lines while moving and directors are using tracking shots so Marlon Brando is a blur."[22]

Beyond these lessons in cinematographic technique, however, is again the exploration of our relationship with the temporal. Returning to DuBois's apprehension that we are all "running out of time," by viewing seventy-five years of Best Picture films in seventy-five minutes, we are reminded that the normal scenario of cinematic viewing—in a dark theater, screen flickering before us and exciting our desires (a la Laura Mulvey)—is one that purports to be an experience of duration but is anything but. As Hollywood cinema has evolved, scenes have become shorter, actors have become more animated, special effects have become more bombastic, and our attention spans are taxed not through duration but rather through what Jean Baudrillard deemed "the excess of cinema bringing the illusion of cinema to an end."[23] DuBois's *Academy*, then, stands as the temporal infographic reminding us that our pasts, presents, and futures are but a blur of information in which we, through our own subjectivity, must remind ourselves that "time presupposes a view of time. It is, therefore, not like a river, not a flowing substance. The fact that the metaphor based on this comparison has persisted from the time of Heraclitus to our own day is explained by our surreptitiously putting into the river a witness of its course" and that the *now* is a temporal fluidity in which our consciousness, our witness, is constantly renegotiating its position.[24]

Notes

1 R. Luke DuBois, "Fashionably Late for the Relationship: Some Notes" (New York City, October 1, 2007), http://www.lukedubois.com/, accessed April 20, 2013.

2 See Anne Collins Goodyear's essay in this volume.

3 Erika Rydberg, "The United States of Lonely, Crazy or Sexy? An Infographic Census of Love," *All Tech Considered*, National Public Radio, April 21, 2011, http://www.npr.org/blogs/alltechconsidered/2011/04/25/135379290/the-united-states-of-lonely-crazy-or-sexy-an-infographic-census-of-love, accessed April 29, 2013.

4 R. Luke DuBois, in discussion with the author, [February 2012].

5 Robyn Gee, "19 Million Profiles Later...Online Dating Lingo Tapped and Mapped," *Turnstyle* (April 5, 2011), http://turnstylenews.com/?s=dubois, accessed April 30, 2013.

6 Rydberg, "United States of Lonely, Crazy or Sexy?"

7 Joshua Decter, "R. Luke DuBois: Bitforms Gallery," *Artforum*, April 2011, 218.

8 Maurice Merleau-Ponty, "Temporality," in *Time*, ed. Jonathan Westphal and Carl Levenson (Indianapolis: Hackett Publishing, 1993), 180.

9 All technical information was supplied by the artist in conversation with the author. See also DuBois, "Fashionably Late for the Relationship."

10 Ibid. On the score accompanying Sifuentes's performance in the final film, DuBois states, "The aim was to have the violin playing assert a series of moods, or gazes, upon Lián when she was on the set... the breaks in her performance serve as breaks in the different parts of the score resulting in a programmatic work that covers a lot of different styles."

11 Ibid.

12 Each of these traits is explored at length in DuBois, "Fashionably Late for the Relationship."

13 Ibid.

14 Interest in the manipulation of time through the speeding up and slowing down of film is certainly nothing new. Early experimental filmmaking by the Dadaists and Surrealists, among others, certainly exploited this inherent ability of the medium. DuBois, however—through the use of high-definition video, powerful computers, and computer software—is able to achieve levels of manipulation that were heretofore unobtainable.

15 Merleau-Ponty, "Temporality," 188.

16 Ibid.

17 Ibid.

18 Ibid., 178.

19 See the project notes on DuBois's website, http://www.lukedubois.com/, accessed April 30, 2013.

20 Ibid.

21 Ibid.

22 R. Luke DuBois, in discussion with the author, April 30, 2013.

23 Jean Baudrillard, "Aesthetic Illusion and Disillusion," in *The Conspiracy of Art: Manifestos, Interviews, Essays*, ed. Sylvère Lotringer, trans. Ames Hodges (Cambridge: MIT Press, 2005), 112.

24 Merleau-Ponty, "Temporality," 178.

Visualization— The Art of R. Luke DuBois

Anne Collins Goodyear

"Reflection is the courage to make the truth of our own presuppositions and the realm of our own goals into the things that most deserve to be called into question."[1] —Martin Heidegger, 1938

As an artist, R. Luke DuBois tests the limits of representation, deeply probing its assumptions and seeking, with a strong dose of humor, to upend them. Rooted in the contemporary world of data, DuBois seeks to make sense of the information that both engulfs and shapes those of us who are creatures of the virtual electronic environment delivered to us through the portal of our computer screens. Daily communication, information gathering, and routine tasks continually reinforce our connection to computers, tablets, and mobile phones. Who has not heard of Facebook? Who has

FIG. 1. Detail, *Sergey Brin and Larry Page*, 2013. National Portrait Gallery, Smithsonian Institution; supported by a grant from the Donald W. Reynolds Foundation and by the Marc Pachter Commissioning Fund.

not snapped and instantly sent pictures of themselves and their friends around the world? Who can claim to have avoided the gaze of the computer's screen and conformed his or her behavior, communications, and perhaps very appearance to match its demands? As I write, I become increasingly aware of the small lens built into the screen of my laptop, just waiting to beam my likeness anywhere. Does it merely await my command?

Exploring the political and personal implications of a world that has become a picture—a topic famously taken up three-quarters of a century ago by Martin Heidegger[2]— DuBois playfully questions the nature of the apparent spectrum of possibilities, our behavior, and our very sense of self in a world that might aptly be described today, not so much as a "picture," but as a "visualization." However, just as many scholars have deconstructed the cultural assumptions implicit in the seemingly "natural" rendition of three-dimensional structures through the devices of linear perspective, photography, and other means, DuBois teases apart the very modes of organization that give meaning to the vast realm of data that we use to define our universe and our position in it.[3] Thus, DuBois, to paraphrase Walter Benjamin, brushes visualization against the grain, dismantling and reconfiguring the world around us and affording new modes of visibility, even as

he exposes our assumptions.[4] As DuBois explains, "I'm drawn to information-space versions of what we used to refer to in media-space as 'culture-jamming,' using the tools of a particular established medium to critique it."[5]

Visualizing the World

"We are drowning in information, and we can't keep up," observes DuBois. "Just as data visualization helps us to make sense of the 'facts' of our world, art made with data lets us look critically at those 'facts.'"[6] Deliberately problematizing the very adequacy of the interpretative frameworks we use to discern "truth" (in other words, "the facts"), DuBois testifies to the ability of art—his art—to recast the modes of picturing that seem to define our world.

The phenomenon of human knowledge, assumptions, and intellectual frameworks fashioned as something pictorial rests at the heart of Heidegger's 1938 essay, "The Age of the World Picture." As the philosopher observed, "world picture, when understood essentially, does not mean a picture of the world, but the world conceived and grasped as picture. What is, in its entirety, is now taken in such a way that it first is in being and only is in being to the extent that it is set up by man, who represents and sets forth."[7]

Picture, as a metaphor for the paradigmatic organization of information and perception, has the value of suggesting the potential for scaling, as Heidegger himself recognized: "A sign of this event [the acceptance of the world as picture] is that everywhere and in the most varied forms and disguises the gigantic is making its appearance. In so doing, it evidences itself simultaneously in the tendency toward the increasingly small."[8] The presumption of such scalability is essential to Alexander Galloway's recent analysis of the role of the "interface"—a distinctly visual metaphor—in navigating the dense networks of information that dominate the conceptual maps we use to navigate the world of the twenty-first century. Galloway asserts: "Today all media

are a question of synecdoche (scaling the part for the whole), not indexicality (pointing from here to there)."[9] It is arguably just such a belief in the analogical relationship between the part and the whole that enables data sets to represent both microcosms and macrocosms—a supposition critical to navigating the World Wide Web, which beckons to us on the other side of our computer screen.

Analyzing the "interface," a richly pictorial model to describe the mode through which today's virtual—and intellectual—world manifests itself to us, Galloway writes (seemingly implying if not deliberately invoking Heidegger's description of the world picture): "While readily evident in things like screens and surfaces, the interface is ultimately something beyond the screen. It has only a superficial relationship to the surfaces of digital devices, those skins that beg to be touched. Rather, the interface is a general technique of mediation evident at all levels; indeed it facilitates the way of thinking that tends to pitch things in terms of 'levels' or 'layers' in the first place. These levels, these many interfaces...show that the social field itself constitutes a grand interface, an interface between subject and world, between surface and source, and between critique and the objects of criticism. Hence the interface is above all an allegorical device that will help us gain some perspective on culture in the age of information."[10]

While Galloway's analysis of interface and its ideological implications demands sensitivity to the phenomenon of visualization, the media theorist recognizes that "any visualization of data must invent an artificial set of translation rules that convert abstract number to semiotic sign. Hence it is not too juvenile to point out that any data visualization is first and foremost a visualization of the conversion rules themselves, and only secondarily a visualization of the raw data."[11] Drawing our attention to the conversion regimes that render the translation as invisible as possible, Galloway argues: "Only one visualization has ever been made of an

FIG. 2. Detail, *Sergey Brin and Larry Page*, 2013. National Portrait Gallery, Smithsonian Institution; supported by a grant from the Donald W. Reynolds Foundation and by the Marc Pachter Commissioning Fund.

information network."[12] Pointing to the "hub and spoke cloud aesthetic" of the organization of information on the Internet, a model that is indeed ubiquitous,[13] Galloway despairs of any meaningful mode of differentiation, ultimately concluding: "At one extreme, information aesthetics fails because it is unable to take alternative forms, escaping from the shadow of the predominant form. At the other extreme, information aesthetics fails because it adopts one form at the expense of all others. Mediation is missing. There is, in a very literal sense, no media happening here."[14]

If the "hub-and-spoke" charts problematized by Galloway occupy an important place in the work of DuBois, they do so not as conceptually transparent elements. Instead, DuBois transforms these visualizations into aesthetic elements themselves, turning them to unconventional ends. Rather than analyzing workflows or assessing troop movements, thereby transforming the human into abstract, seemingly objective trends, DuBois instead trains these tools upon the subjective: human relationships, personal feeling, and the very question of individual identity. Challenging the vast scales of data that render individuals as global trends, DuBois shifts his visual to the unit of the human

being. Instead of providing answers, his visualizations question the very nature of that which is most intimate: the sensations and associations that define us as people.

Visualizing Google

It is perhaps not inappropriate, then, that data visualization should become, for DuBois, a mode of rendering the technological personal—a means of portrayal—a device for giving a face, as it were, to Google. Perhaps no tool more than Google has been responsible for building widespread reliance upon the Internet as a source of information for the general public. While not the first search engine, Google is unquestionably the most dominant, mapping the data terrain for its users and creating an impression of comprehensiveness and reliability.

The transformative influence of Google's platform—which creates an easily navigable form to peruse and comprehend otherwise amorphous data, fulfilling the company's mission "To organize the world's information and make it universally accessible"—has been widely noted, and "our increasing, uncritical faith in and dependence on it" has become a subject

FIG. 3. Video still,
Moments of Inertia, 2010.

of critique.[15] Indeed, arguably, Google's power in large part derives from its ability to make information visible and thus digestible via algorithms. The founders' world has become ours. As David Joselit recently observed: "Already in 1998, Google recognized the necessity of giving the vast reserves of data on the World Wide Web a shape, even in the absence of a viable business model for capitalizing on it. Now it is one of the most financially successful corporations of the early twenty-first century, and for a simple reason: in informational economies of overproduction, value is derived not merely from the intrinsic qualities of a commodity (or other object), but from its searchability—its susceptibility to being found, or recognized (or profiled)."[16]

But what does it mean to "profile" or "Google" the very creators of this technology that undergirds the attempts of virtually any computer user to gather vital information, from healthcare to restaurant choices? DuBois's recent portrait of Larry Page and Sergey Brin both "facializes" the technology and draws attention to the very absence of the auratic self from Google's web pages. As Alex Galloway has observed, "Profiles, not personas, drive the computer."[17]

Commissioned by the National Portrait Gallery, DuBois's portrait captures the founders as "Google-able" public figures (FIG. 1).[18] Just as Daniel Boorstin observed the rise of "pseudo-celebrities" produced by the mass media of the twentieth-century, so DuBois charts the development of the "virtual persona"—the alter ego that attends each one of us whose recorded effigy resides in the ether, waiting, as Joselit suggests, to be "searched," and thus to be found and rendered present.[19]

Seeking to disrupt, or at least draw attention to, the illusion of transparency that pervades the environment constructed by the information that Google so effortlessly provides, DuBois treats Google as a medium unto itself. He explains: "[My] intention in the piece is twofold: one, to deliver a portrait of these two men in dialectic with their technology in a way that highlights their singular contribution to our world while provoking questions about our relationship to their invention; and two, to reorient the viewers' relationships to these men and their

FIG. 4. Video still,
Moments of Inertia, 2010.

invention by inverting the flow of information. In normal usage, we place our questions to Google (the website), and the results are returned using algorithms developed by their founders. In this portrait, the founders pose the questions, and we become privy to a unique, constantly evolving, artistic interpretation of the results."[20]

DuBois's artwork consists of two screens. One contains clips from 1997 to the present that feature the founders of Google (FIG. 2). Broken into short segments, they are tagged with meta-data descriptions that enable a program created by the artist to play them back in unpredictable sequences. As DuBois notes, "These interviews are edited and automatically subtitled using a combination of YouTube subtitling and Android speech recognition technology (both of these technologies are owned by Google)."[21]

The clips, in turn, are linked to the Internet—to Google's own search engine—generating associative results of images and other words. The pictures pulled up by the searches are then superimposed, tattoo-like, over the "talking heads" of the founders, creating a screen that

shapes their very appearance. The words, meanwhile, manifest themselves on the flanking screen as data clusters resembling the night sky. They spontaneously change and take on new configurations as Google spawns new "hits" on the data points correlated to the words used by the founders in their public statements.

According to DuBois, the work is "a portrait in data. This data takes many forms, visual and aural, moving and still, vector and raster, text and image. All of this data, mined from the Internet using software developed by the artist, focuses on Brin and Page and their use of language in public-facing interviews that they've given over the last fifteen years. Their lexicon and verbal mannerisms are then fed into their own search engine, with the results providing data that drives a synchronized, synesthetic visualization of their prosody and vocabulary."[22]

In submitting likenesses of the founders, and their very remarks, to the seemingly invisible (to our eyes and minds) conceptual transformations and associations Google and its related technologies enable, DuBois creates a portrait of the engineers that embodies,

i dream of you you wrote are they blossoming into something more then you could have ever imagined at night when those eyes of yours i swam in close █ do you dream the fondest of dreams . giving life to stories you've yet to write . im sure he is a nice guy and all . but he is he . and i am me . i know how i made you feel . you chose to play it safe . he does seem pretty silly . but its best to be silly at the right moments . the fire i stoked ignited another man land . . is could he keep it burning . i never got to know you . i loved the little i did . you know me very well i heard that there are many different shades of blue . so . what do you dream of .

i was walking my dog when i turned a corner and noticed you walking in front of me big hair and a tiny skirt . you were cute . at some point you looked over your shoulder . noticed me and pulled down your skirt . i hope i didn't scare you . after all . a man can't help but notice .

FIG. 5. Screen shot, *Missed Connections*, 2012.

virtually, the information structures they themselves constructed.

If the mode of manipulation of data by Google is a set of algorithms, set into a digital universe, we might properly label such methods "mathematical." Indeed, the deeper implications of doing so are suggested by Heidegger: "Ta mathēmata means for the Greeks that which man already knows in advance of his observation of whatever is and in his intercourse with things: the corporeality of bodies, the vegetable character of plants, the animality of animals, the humanness of man. Alongside these, belonging to that which is already-known, i.e. to the mathematical, are numbers." The mathematical then, is not arithmetical per se, but rather corresponds to a mode of understanding the world, of seeing it, which functions by means of basic assumptions that structure meaning. Heidegger continues: "Every event must be seen so as to be fitted into this ground plan of nature. Only within the perspective of this ground plan does an event in nature become visible as such an event."[23] Thus, the mathematical organization by Google of the information that courses around the globe both presumes and in turn potentially demands that what is truly meaningful will correlate to paradigms that are essential to its functioning.

Inertia

"How much effort does it take to change your life's direction?" So begins DuBois's *Moments of Inertia* (2010), a musical composition for violins that combines multi-channel video (FIGS. 3 AND 4). He observes: "How much effort does it take to change your life's direction? How do you calculate the inertia of your relationships or your career? How do you determine the effort required to move across the country to be with someone you love, or move three

FIG. 6. Screen shot, *Hard Data*, 2009.

barstools down to talk to someone you find attractive? What is the resistance value of making eye contact, or of saying you're sorry? Even in a society that prides itself on mobility, we all have our moments of inertia."[24]

Applying a scientific and mathematical principle used to describe the motion of bodies to a social phenomenon, DuBois speaks to what may be the larger agenda of his work: revealing the social and intellectual significance of a world that seems to control our choices and our very behavior. Such a deeper significance seems to be at play in two artworks that examine the problem of romantic love in the contemporary era. Playing with the very question of personal data that is voluntarily delivered by citizens, DuBois developed *Missed Connections* and *A More Perfect Union*.

Missed Connections builds on the Craigslist tool of the same name in an effort to unite potentially "perfect" partners (FIG. 5). Searching the Craigslist site, DuBois's

algorithm generates matches between the postings of frustrated romantics who believe they have met "the one." The resulting visualization of the data takes on the appearance of a flight plan simulator—perhaps referencing other sorts of "missed connections"—or any other schematic depiction of movement (Galloway's "hub and spoke" model). While the artist himself has tried—unsuccessfully—to make the program work, and encourages others to "play Cupid" as well, the impersonal nature of the resulting image seems to thwart the intimate nature of its purpose. Can human love be mathematically determined? Or does its very idiosyncratic quality elude the world model presupposed by such a program?

A More Perfect Union similarly juxtaposes two large data sets, seemingly reflecting the resistance of the personal to the capacity to schematize it as data. Inspired by information gathered from the 2010 census, DuBois took his own "census" of American life by contributing

his personal information to twenty-one dating sites and mapping the results he received from respondents. Mimicking U.S. maps that use color to represent political predilections (red signifying a conservative bent and blue a more liberal one), DuBois instead redefined red as female and blue as male. In maps of each state and various cities, he pinpointed the word most commonly used by residents to describe themselves, creating a new "picture" of the United States and recasting the very meaning of the political census that is readily taken for granted by most citizens.

The Visualization of Politics

As Galloway observed, "The point of power today resides in networks, computers algorithms, information, and data."[25] In similar form, DuBois notes, "Politics in the twenty-first century, especially in the United States, is all about controlling and mediating the flow of information; whoever has the best grasp on the twenty-four-hour news cycle wins the debate.... The last century's mediatized channels of discourse and protest seem quaint in the age of leveraged social networking and YouTube."[26]

The question of how information is parsed for political purposes undergirds works by DuBois that shed light on the most recent U.S. military conflict in Iraq and the very regime of presidential power that seems to rest behind it. In *Hard Data* (2009; FIG. 6), DuBois creates a musical composition and visualization using various sets of statistics about the war. As the artist notes, "The Iraq war, as an 'American' war, is the first large conflict in which the average American has more data than knowledge."[27] Repurposing the data as the basis for an aesthetic undertaking that also projects data about the war budget, casualties, and other statistics transforms the information from "background noise," which easily passes unnoticed, into something that demands our attention, subverting and reconstructing the narratives it might normally undergird. Reclaiming automatically

generated data for the unconventional purpose of creating art, DuBois recasts the impersonal as something accessible, if not rational, to a human audience, rather than simply something to be digested and parsed by the very computers that rendered the data sets in the first place. DuBois restores the personal element to a conflict that threatens to express itself as mere statistics.

In similar fashion, DuBois makes the political personal with his *Hindsight Is Always 20/20* (2008), which depicts forty-one commanders in chief by transforming their State of the Union addresses into eye charts.[28] Analyzing each president's speech, DuBois determined the frequency with which particular terms occurred—exempting those used by virtually every president, such as "united," "states," "the," "his," "her," and "am." He then distilled the terms, using size to indicate frequency, into the format of the Snellen eye chart, which was developed during the nineteenth-century and is still used today to measure visual acuity. Transforming the texts into another format, one designed to be readable but not decipherable, DuBois created a "snapshot" of each president, starkly revealing the terms associated with the most pressing issues of the day in the eyes of each leader.

— / — / —

Through his focus on the representation of data and his playful reorganization of it from broad abstractions into deliberately human terms, DuBois forces his audience to reflect on their own assumptions, rendering visible the very interfaces that seldom reveal themselves to us. In so doing, he creates a collective portrait of society and the constituents that compose it—with our hopes, fears, expectations, and desires. Through their very invocation of humor, DuBois's projects do not placate; instead they dislodge their audiences into the uncomfortable territory of contemplating that which cannot be contained or measured—that which surpasses the very capacity for visualization—the personal itself.

Notes

1 Martin Heidegger, "The Age of the World Picture," in *Question Concerning Technology and Other Essays*, trans. William Lovitt (New York: Harper and Row, 1977), 116. Heidegger first delivered this paper in 1938. See Lovitt's preface to the same volume.

2 See ibid., 128 and 131–36.

3 See, for example, Jonathan Crary, *Techniques of the Observer: On Vision and Modernity in the Nineteenth Century* (Cambridge, MA: MIT Press, 1990).

4 Walter Benjamin, "Theses on the Philosophy of History," in *Illuminations: Essays and Reflections*, ed., Hannah Arendt, trans. Harry Zohn (New York: Schocken Books, 1968). Benjamin's essay was completed in the spring of 1940. See the editor's note in the same volume.

5 Stephen Squibb, "Hard Data and Hindsight: Interview with R. Luke DuBois," *Idiom* (August 5, 2010), http://idiommag.com/2010/08/hard-data-and-hindsight-interview-with-r-luke-dubois/, accessed April 30, 2013.

6 R. Luke DuBois, quoted in Madeleine Overturf, "Data-based Artwork Eases Analysis with Visual Representation," nyunews.com, April 3, 2013, http://nyunews.com/2013/04/03/data/, accessed April 30, 2013.

7 Heidegger, "Age of the World Picture," 130.

8 Ibid., 135.

9 Alexander R. Galloway, *The Interface Effect* (Cambridge, UK: Polity Press, 2012), 8–9.

10 Ibid., 54.

11 Ibid., 83.

12 Ibid., 85.

13 Ibid., 84–85.

14 Ibid., 86.

15 Siva Vaidhyanathan, *The Googlization of Everything (And Why We Should Worry)* (Berkeley: University of California Press, 2011), 4.

16 David Joselit, *After Art* (Princeton: Princeton University Press, 2013), 58.

17 Galloway, *Interface Effect*, 12.

18 Although the National Portrait Gallery offered an invitation to Brin and Page to participate in this project, it was not possible for them to do so.

19 Daniel Boorstin, *The Image: A Guide to Pseudo-Events in America* (New York: Random House, 1987).

20 R. Luke DuBois, "Sergey Brin and Larry Page," concept statement describing portrait created for National Portrait Gallery, April 23, 2013, curatorial file, National Portrait Gallery.

21 Ibid.

22 Ibid.

23 Heidegger, "Age of the World Picture," 118–19.

24 R. Luke DuBois, "Notes," for *Moments of Inertia*, a composition by R. Luke DuBois and Todd Reynolds, http://turbulence.org/Works/inertia/notes.html, accessed April 28, 2013.

25 Galloway, *Interface Effect*, 92.

26 DuBois, quoted in Squibb, "Hard Data and Hindsight."

27 Ibid.

28 The work, which was completed before the election of Obama, includes forty-one presidents up through the administration of George W. Bush. In order to be included in the project, a commander-in-chief had to have delivered a State of the Union address, thus exempting Presidents William Henry Harrison and James Garfield. See R. Luke DuBois, "Essay," *Hindsight Is Always 20/20*, http://hindsightisalways2020.net, accessed April 30, 2013.

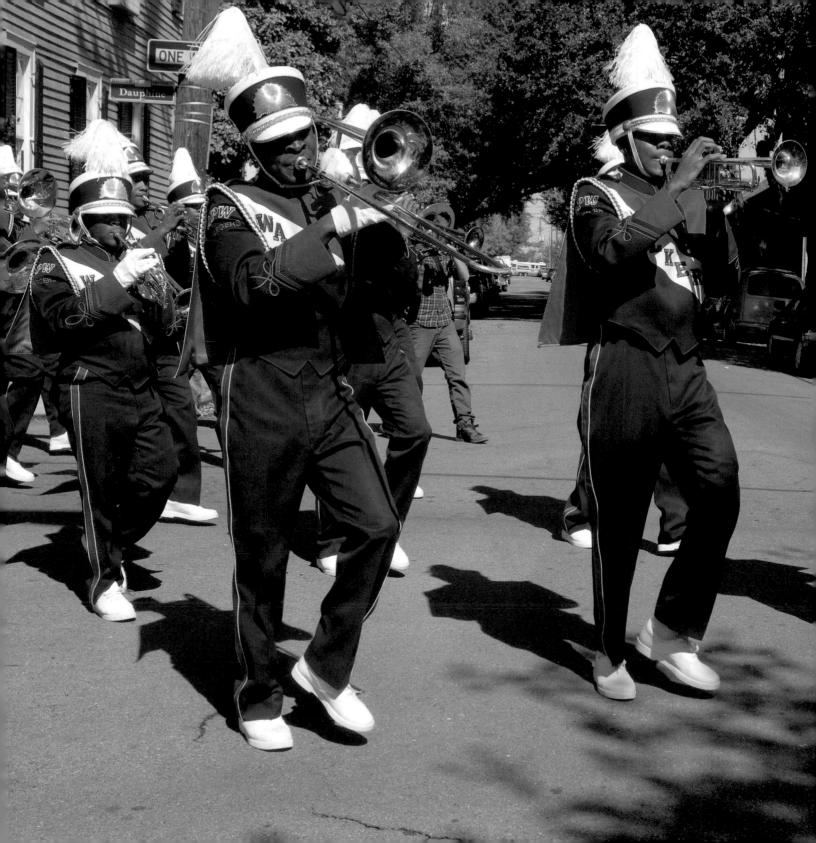

Unfashionably Early for the Art World

Dan Cameron

Most of us like to think that art as a process runs along more or less evolutionary lines, meaning that as civilization advances, the innovations of artists either keep pace with those developments or stay a step or two ahead of them. Furthermore, we tend to believe that art that endures past its historical moment is more likely to be recognized at its moment of creation today than, say, the art of a hundred years ago. Unfortunately, while the former assertion might be tough to argue against, there is very little objective rationale for believing that the latter proposition is really the case. Many artists whose contributions were egregiously overlooked forty or fifty years ago continue to be revived today, and a large number of the bright lights of ten or twenty years ago have already been hidden away, their work a source of embarrassment for their former defenders. In fact, it may be just as true that with the increased popularity of art, the ever-ascending contemporary art market, and the surge in global art issues, it has become harder than ever to determine whose work is truly innovative—work with new forms that express new ideas in an entirely new way.

This issue is particularly germane to R. Luke DuBois, who, over the past decade, has produced a dizzying array of work in a variety of media, including music, performance, video, objects, and large-scale graphic art presented in a public realm. If any single thread links his work, it is the outsized role of information technology. But even this commonality does not begin to describe DuBois's approach to making art, since his work often expresses a highly democratized perspective, in which the techie's, or geek's, base of knowledge is not privileged in the viewer's final experience. On the contrary, much of DuBois's working process consists of bringing to the forefront an idea or cluster of ideas that are relatively easy to describe and share, but that nonetheless require a great deal of technical capability to execute. One can imagine, for example, what it would be like to experience every film that has ever won a Best Picture Oscar at a speed that reduces each movie to exactly one minute each, as in DuBois's *Academy* (2006) but it would be quite a different matter to create such a work, and an even different matter to experience it. The final result is not exactly pleasant, at times bordering on the painful, but it does provide a very powerful reminder that our most cherished cinematic memories depend on combinations of digital signals and tempos that are meaningful to us only within a very narrow band of reality. Outside of that sliver of sense, these beloved artistic creations become as foreign to us as radio signals from outer space.

FIG. 1. *The Marigny Parade*, 2011–12.

The dilemma that DuBois's work presents to most curators and critics is rooted in his complete disinterest in making art that conforms to any previous notions of style. Back in the early era of digital or computer-based art, which more or less occupied the last decade of the twentieth century, artists as diverse as Bill Viola, Julia Scher, and Matthew Barney kept a tight grip on previously held notions of stylistic identity within their work. More than the established "look" of a traditional painter, sculptor, or photographer, however, those artists had a specific range of images, techniques, and palettes that bound their oeuvres together, almost like sequential chapters in a single novel. One recognized a Viola the way one recognized a Warhol, and it was not considered necessary or even desirable to construct a conceptual framework that extended far beyond the visual realm to tie a work to its creator. This unquestioned conformity to established conventions of stylistic identity was never really challenged until the Internet became a substantial factor in human communications, which in turn upended the very idea of what an artwork could be, and how it connected to other works made by the same person(s). The Internet soon became a kind of rogue art world, in which the economics and accompanying star-making machinery of the market never really entered the discussion. The quasi-anonymity of the authors of early Internet-based art was also predicated on the fact that almost nobody expected such art to actually be sold, which in turn made the recognizability of the artist a moot point.

This is not to say that stylistic eclecticism was unheard of prior to DuBois's emergence. On the contrary, one of the hallmarks of the 1990s was the breakdown of hegemonic stylistic concerns, and the resulting absence of any definitive connection between the artistic approaches embodied by a particular work and the period in which it was made. Prior to the 1990s, styles lived and died according to such periods, and once Pop Art, say, had made its initial splash, there was no possibility

for latter-day Pop artists to enter the fray; the doorway of innovation had shut tight. By the 1990s, however, pluralism dominated artistic developments, and suddenly realism, expressionism, conceptual art, and minimalism could all co-exist, often in the same gallery. But this collapse of schools and movements was mostly restricted to the world of objects and their creators, and it had little to do with the future of technological possibilities within art.

For DuBois, the condition of having an artistic profile that is hard for a casual observer to grasp is not rooted in a willful act of negation, but in his early recognition of the infinite number of operations that could be performed relative to the passing of time. For example, in his well-known 2007–08 work, *Fashionably Late for the Relationship*, DuBois combines public art and performance in the first stage of the piece, which requires a female performer to dress, smoke a cigarette, apply makeup, and make a phone call—all while under a canopy in the middle of a busy Manhattan intersection. The visual hook of the piece stems from the fact that the woman performed those tasks at an incredibly slow pace, so that a range of activities that might have required fifteen or twenty minutes in real time was stretched out to thirty-six hours. All of it was videotaped by the artist, then sped up in the final cut to make her actions seem natural and relaxed, while outside of her transparent walls, the world rushes by at a fevered pace, with people and vehicles reduced to incomprehensible blurs. Confronted with these conflicting images of reality—one in which human effort seems languid and unforced, and the other in which the outside world is a hazy blur—any viewer of the final cut is hard-pressed to invest any confidence in what she or he is seeing.

DuBois is a master computer programmer, a fact that frequently lends his artistic research the inventor's incipient need to reach conclusions that are tangible and meaningful in the nongeek universe. For example, his project for the 2008 Democratic National Convention

in Denver, *Hindsight Is Always 20/20*, used language-analysis software to render each U.S. president in terms of the words they used most frequently in their State of the Union addresses. Printed as large-scale light boxes that were highly visible to attendees of the convention, the works made use of software that was only beginning to come into general use (FIG. 2). DuBois's approach combined politics, history, and language to produce an unprecedented artwork that crystallizes the tensions of a country emerging from the dumbed-down, war-mongering language of the George W. Bush administration, and on the cusp of electing the first non-white president, whose language is several notches above his predecessor in terms of ability to articulate subtle ideas with well-crafted sentences and paragraphs. At the same time, *Hindsight Is Always 20/20* captured America's

increasing fascination with the rapidly expanding powers of the Internet, and it made a convincing case for the essential role of public debate in the long-term interests of democracy.

Two years later, DuBois took on one of the most broadly ridiculed parts of the Internet universe, online dating, and used it to develop an even more compassionate portrait of the country. Mapping every city and neighborhood in the United States according to the words most used by people in each place, he created a detailed map of all fifty states, in which the actual place names were replaced by those terms. The interplay of pathos, aggression, self-aggrandizement, and shame is richly illustrated by the pattern of internalizing the group identity of a place through the individual identities of would-be daters, who are in all likelihood unaware that

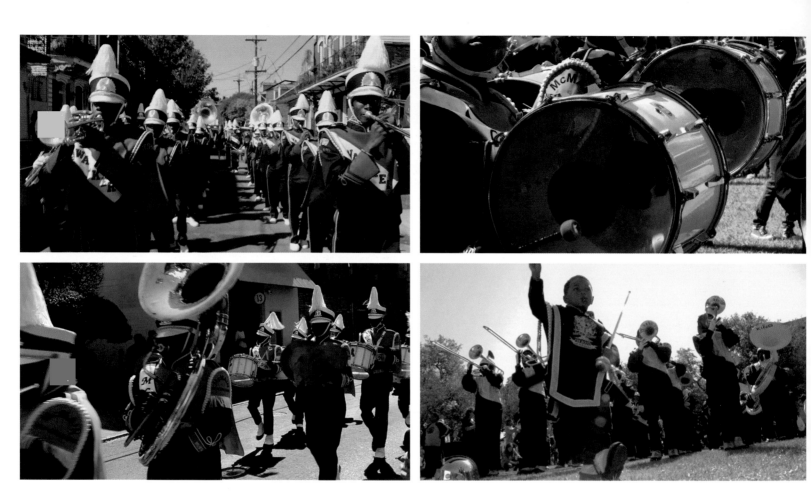

FIG. 3. *The Marigny Parade*, 2011–12.

they have used the same words to describe themselves. Like *Hindsight Is Always 20/20*, *A More Perfect Union* uses quite sophisticated software to create a compound image that is at times poignant, and is universally comprehensible to even the most tech-averse viewers.

DuBois's obsession—it is not too strong a word to use here—with time stems from his background in music, in which he majored at Columbia University. Not many of his works result in musical compositions, but the ones that do are among his most engaging investigations. In 2011, I had the immense privilege of collaborating with the artist on a work called *The Marigny Parade* (FIGS. 1 AND 3). The concept of the work was rooted in the extraordinarily fertile brass-band tradition of New Orleans, which finds its most endearing manifestation in the high visibility of middle and high school marching bands. DuBois's project was also predicated on the following idea: If one of the most engaging sounds is that of a brass band–led parade approaching from a distance, that pleasure could be compounded by having several brass bands converge on the same place from different directions. With this framework, DuBois worked

closely with three public school music directors in New Orleans to develop a fairly simple musical composition that could be performed with relatively little rehearsal. After dividing his musicians into four groups—each of which was stationed at a different distance from Washington Square Park in the Marigny neighborhood—DuBois ensured that each bandleader was connected via earphones to a universally broadcast click track that indicated exactly which part of the composition each group was playing, so that each one was in perfect synchronicity with the others (FIGS. 1 AND 3). Although each group started with the same downbeat as the others, there was no way to determine whether or not they were playing in unison until all four groups arrived in full-dress uniform at the park and began playing together with a heightened degree of zeal, once they realized they were in perfect rhythmic counterpoint with each other.

Over the past few years, the art world has belatedly discovered that performing arts can provide an illuminating complement to the visual arts. This seems to have narrowed in on composers and musicians, but rarely on visual artists who are proficient in both fields. One exception is the heightened visibility of Christian Marclay, who pioneered the art-music synthesis more than thirty years ago, and who also was mostly overlooked by the mainstream art world until he shifted the course of art history with his monumental video work, *The Clock*. Like Marclay, DuBois is in the less-than-enviable position of being recognized and respected by his musical peers at a moment when his greatest artistic achievements seem to be lost on the average viewer, who is probably unfamiliar with his name. With the present survey of his work, however, it is finally possible to imagine those who do not know how to categorize DuBois's art dropping the need to label it, as they begin to appreciate how many boundaries he has crossed in such a relatively short period of time. As his achievements are disseminated among a broader audience, one can only hope that his precedent-shattering approach to

artmaking will become more the rule than the exception. Perhaps the age of making truly interdisciplinary work that combines traditional ideas of music and high-tech notions about art has finally arrived.

Catalogue

1996–2013

Liner Notes by R. Luke DuBois

2013 **Sergey Brin and Larry Page**

2012 **Acceptance**

2012 **Vertical Music**

2012 **Missed Connections**

2011–12 **The Marigny Parade**

2010–11 **A More Perfect Union**

2009–10 **a year in mp3s**

2010 **Pop Icon: Britney**

2010 **Moments of Inertia**

2010 **Kiss**

2009 **Hard Data**

2008 **Hindsight Is Always 20/20**

2007–08 **Fashionably Late For The Relationship**

2006 **Academy**

2005 **Play**

2005 **Billboard**

Performance Collaborations

2010–12 **LOSTWAX, with Jamie Jewett**

2008 → **((((PHONATION)))), with Bora Yoon**

2005 → **Still Life With Microphone, with Todd Reynolds**

2006 → **Bioluminescence, with Lesley Flanigan**

2005 → **Fair Use, with Matthew Ostrowski and Zach Layton**

Older Work

2000–07 **Synaesthetic Objects**

2003 **L-Systems pieces (Applications of...)**

1996–2003 **The Freight Elevator Quartet**

Sergey Brin and Larry Page

Two-channel generative high-definition video with color and sound

2013

Sergey Brin and Larry Page is a generative, 2-channel video portrait that was commissioned by the National Portrait Gallery. The eponymous subjects of the work—the co-founders of Google—are portrayed using documentary interviews found on YouTube. Subtitled by Google technology, the footage is subjected, word by word and phrase by phrase, to Google text and image searches that are visualized in real time as the subjects speak.

Larry Page (b. East Lansing, Michigan, 1973) and Sergey Brin (b. Moscow, USSR, 1973) are responsible for delivering the vast quantity of information on the Internet to the average human user through the Google search engine. Despite being in its twelfth year of existence, that work of software engineering is at its core based on a seminal paper entitled "The Anatomy of a Large-Scale Hypertextual Web Search Engine," which was written by the pair in 1998 when they were 25-year-old Ph.D. students at Stanford University.

To "Google" something is to search for it online. In addition to joining the annals of genericized trademarks (for example, Aspirin or Kleenex), for many of us Brin and Page's company provides the key puzzle piece to unlocking the Internet: the ability to find what we need to know. The sheer ubiquity and breadth of the use of Google makes a portrait of their founders a challenging proposition, given the risk of their invention overshadowing their humanity. My intention in the piece is twofold: one, to deliver a portrait of the two men in dialectic with their technology in a way that highlights their singular contribution to our world while provoking questions about our relationship to their invention; and two, to reorient the viewer's relationship to the men and their invention by inverting the flow of information. In normal usage, we place our questions to Google (the website), and the results are returned using algorithms that its founders developed. In this portrait, the founders pose the questions, and we become privy to a unique and constantly evolving artistic interpretation of the results.

The piece presented here is not a formal, seated portrait, but rather a portrait in data. This data takes many forms, visual and aural, moving and still, vector and raster, text and

image. All of this data, mined from the Internet using software developed by the artist, focuses on Brin and Page and their use of language in public-facing interviews that they've given over the last fifteen years. Their lexicon and verbal mannerisms are then fed into their own search engine, with the results providing data that drives a synchronized, synaesthetic visualization of their prosody and vocabulary.

Artist Statement for the NPG, written 2013

Sergey Brin and Larry Page

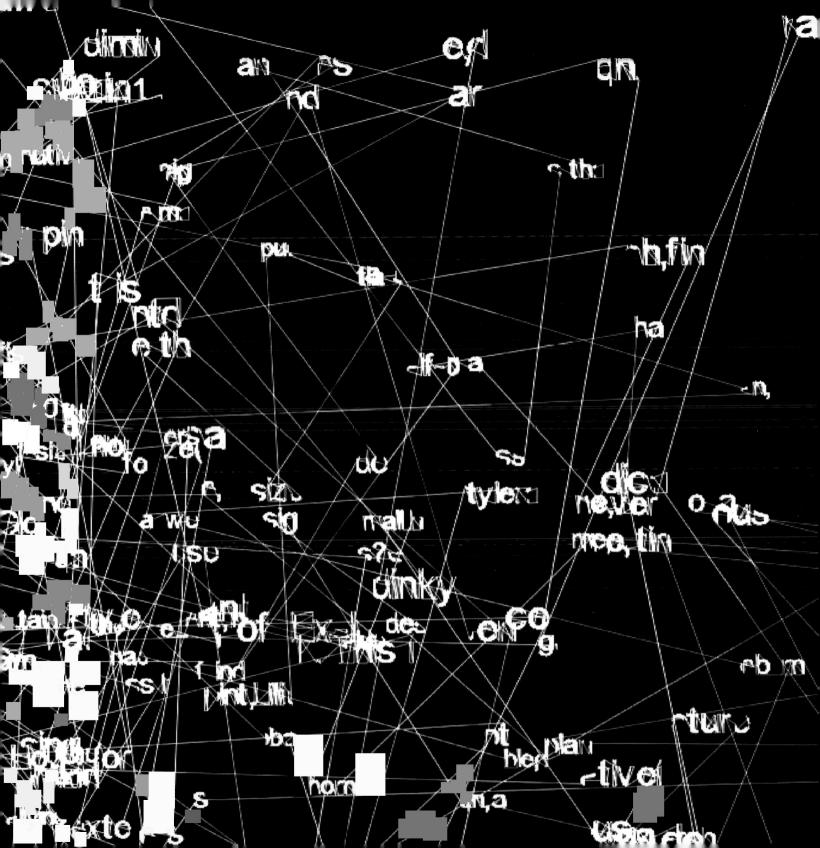

Acceptance

Generative hi-definition video with color and sound

2012

Acceptance takes the acceptance speeches given
by President Barack Obama and Governor Mitt
Romney at their respective party conventions
in 2012, and subjects them to a never-ending
editing process based on their language. The
two monologues, each approximately 40 minutes
long, contain around 1500 unique words, 85% of
which overlap between the two speakers. The
piece synchronizes, whenever possible, the two
candidates' language, so that they deliver each
other's speeches in synchronicity. The work
regularly alternates between which candidate
is the rhetorical leader, so that one video is
always playing in a linear fashion while the
other jumps around to match the other speaker's
vocabulary. This never-ending acceptance
speech highlights both the similarities and
differences in the speaking style, rhetoric, and
body language of the two men vying to be elected
President of the United States in 2012.

- - - - -

wall text for the Lawrence Arts Center,
written 2012

Vertical Music

For twelve musicians, filmed at high speed
2012

Vertical Music is the first in a series of pieces I've envisioned that use high-speed recording equipment to capture musical performance. The four-and-a-half-minute chamber piece for twelve players, was designed to be listened to at one-tenth its original speed (roughly forty-five minutes). Recorded using 300fps cameras and high-definition audio recording, the work-along with *The Marigny Parade* and *Fashionably Late for the Relationship*-looks at alternative ways of viewing the documentation of a performance. The documentation becomes an art form in its own right, with potential for the exploration of time, nuance, and gesture.

Performers:

top row

Jodie Rottle-flute

Stuart Breczinski-oboe

Carlos Cordeiro-clarinet

Kevin Baldwin-tenor saxophone

middle row

Sam Nester-trumpet

Yumi Tamashiro-marimba, percussion

Erika Dohi-piano

Lisa Dowling-contrabass

bottom row

Leah Asher-violin

Tema Watstein-violin

Hannah Levinson-viola

Meaghan Burke-cello

liner note, written 2012

Missed Connections

Website

2012

Missed Connections is a web-based project that scrapes the Craigslist feed of the same name in one of several cities. It then randomly matches ads, looking for pairs of listings that might refer to one another. If the vocabularies of the two ads are similar enough, you have the option of replying, telling the people who posted them that they might be looking for one another. The work uses a lexical matching algorithm that emphasizes unusual words (given names or place names) over quotidian ones.

- - - - -

liner note, written 2012

. as i'm sure you know . ███ ██s been a bit since i ve posted
█ get on with my life . after that last encounter . it seemed
█ . and right in front of me . that's what you were doing .
. i can't fault you for that . i do . still . fault you for
ctions . i was left confused . hurt . and set aside . but .
that . life is challenging enough . so here we are now .
doing in your life with the limited knowledge i'm given . huh .
█ can say . i know you're good at pulling up those boot
does that leave us . has anything changed . it's never easy .
til i see you . or hear from you i will keep on as i have .
volved in any way with me until then . i've had to pull back on
pain and confusion at times . especially after opening my eyes
me . i've tried hard to directly communicate . but you've som
on't

age 48 last night with a friend when i noticed you hanging out
st floor . you had short dark hair . light browntan skin . an
white iphone i think and an absolutely stunning gaze . i was
ailing separating the vip area and our eyes met briefly at one
your way upstairs to the second level and once more when you
roach you but didn't do so out of a desire not to be rude to my
now regret and i'm hoping you or someone that knows you can
touch .

The Marigny Parade
Performance and DVD
2011–12

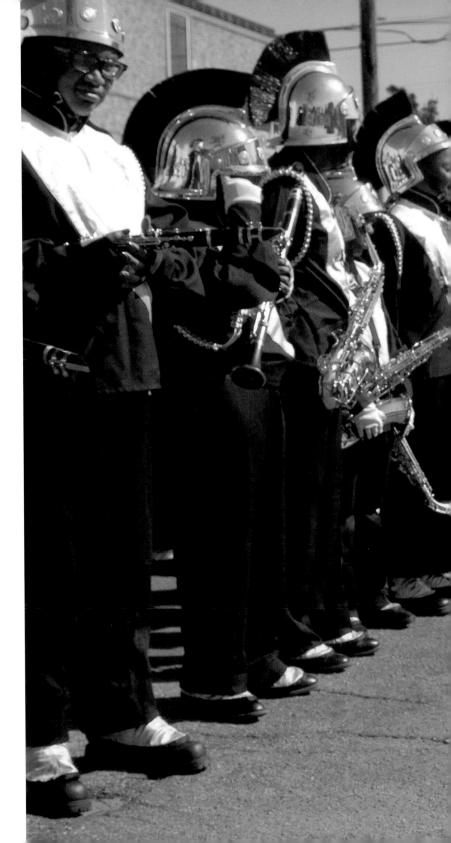

The Marigny Parade was a twenty-minute
performance that was presented, once and only
once, in the Marigny Triangle of New Orleans,
Louisiana, on October 22, 2011. The performance
consisted of a multipronged parade of 350
middle- and high-school marching band musicians
from New Orleans. Synchronized by a radio
click track, they paraded from five different
directions toward Washington Square (a park
in the Marigny), performing a composition of
simple, interlocking loops that I composed
based on contemporary repertoire performed by
New Orleans marching bands. The audience could
follow each band as a second line or await their
arrival in the park. The bands entered the park
one by one, building the music toward a finale.
A fifty-person video- and sound-recording crew
documented the performance, resulting in a DVD
released by Cantaloupe Music. The DVD consists
of five different remixes of the performance
documentation, ranging from a documentary-
style cut with the point of view of one band to
an ambient remix of all of the footage. Five
thousand copies of the DVD were released, in
order to raise money for Roots of Music, a New

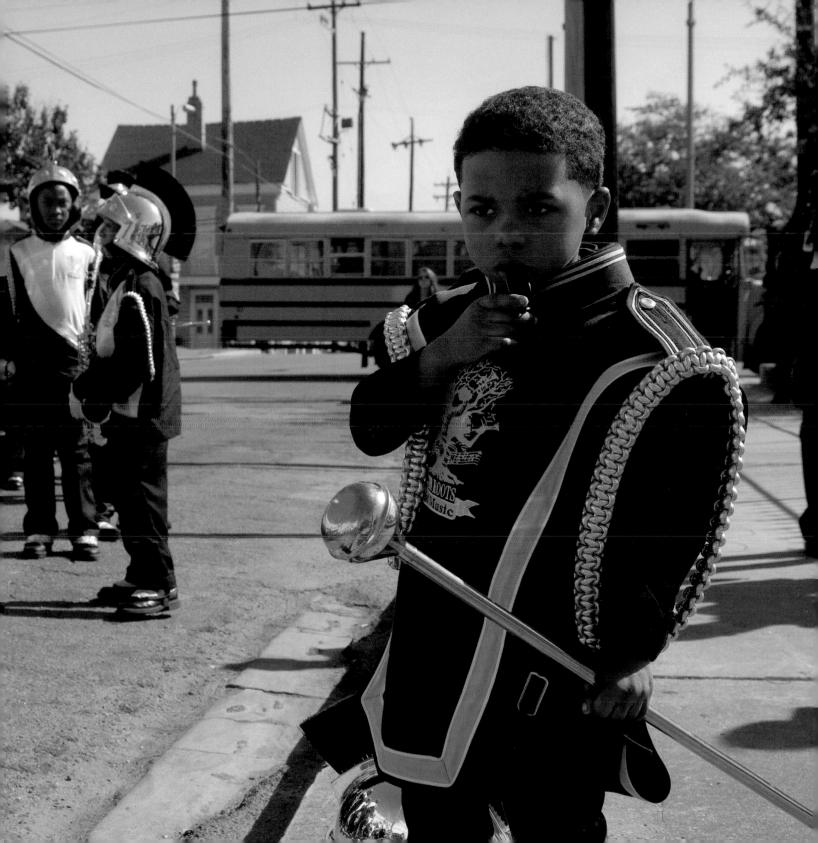

Orleans-based after-school program that teaches
marching band musicianship to at-risk middle-
school students citywide.

Throughout the project I served as composer,
director, and video editor. Dan Cameron, curator
of PROSPECT: New Orleans, commissioned the piece
for the opening ceremonies of the 2011 biennial.
The New Orleans Video Access Center (NOVAC),
working alongside my New York-based production
team, produced the project.

online description, written 2011

Original liner note from the Cantaloupe Music Recording of The
Marigny Parade (2011):

ON OCTOBER 22ND, 2011
SEVERAL HUNDRED YOUNG NEW ORLEANS MUSICIANS
PARADED THROUGH FAUBOURG MARIGNY

New Orleans is music. There is no escaping this fact. 365 days a year, unlike the street parades. 24 hours a day, unlike the food. Indoors and outdoors, no matter how hot it is. People from New Orleans breathe music, and it provides the streets with their air, the muffled sound leaking out of clubs, playing tinny out of sidewalk radios and, most magnificently, resonating between the buildings when the city is in parade. The bands of New Orleans provide the blood for this arterial flow; the carbon dioxide exhaling through their instruments becomes everyone else's oxygen.

Without New Orleans, there would have been no Sun Records in Memphis, Tin Pan Alley in New York, or Motown in Detroit. The city is the origin of American music, without which we would be immeasurably diminished as a culture.

Thanks for listening.

R. Luke DuBois
New York City / October, 2011

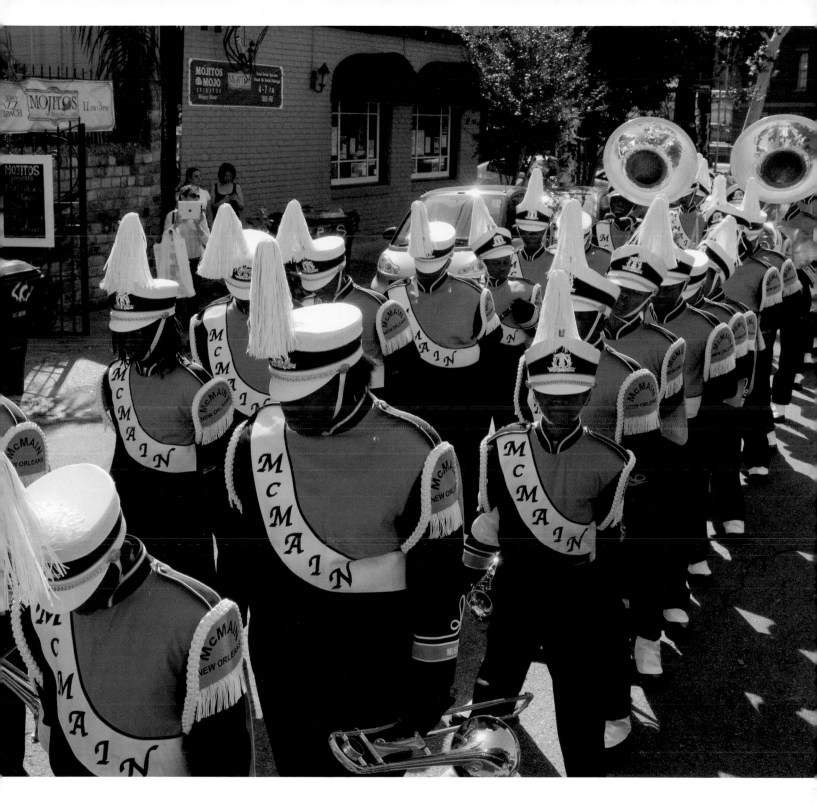

The Marigny Parade

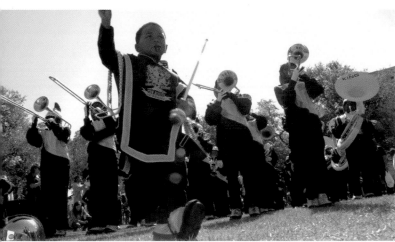
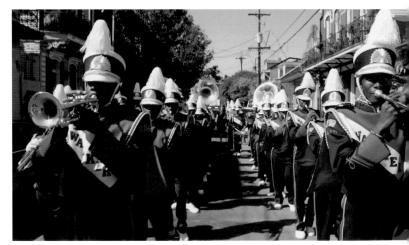
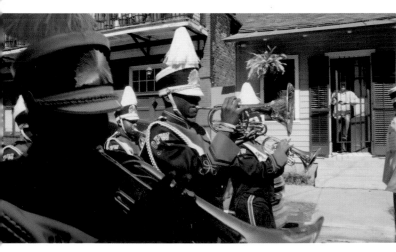
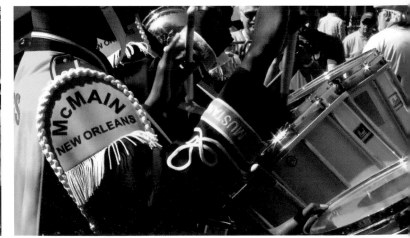

R. Luke Dubois — Now

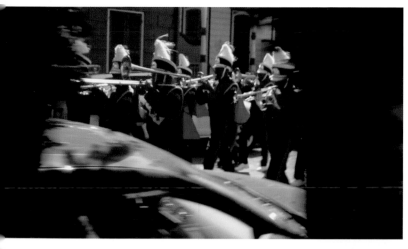
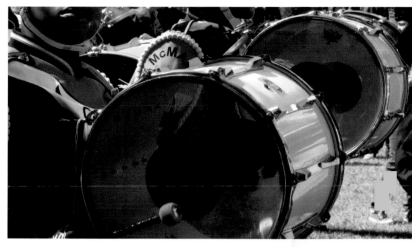
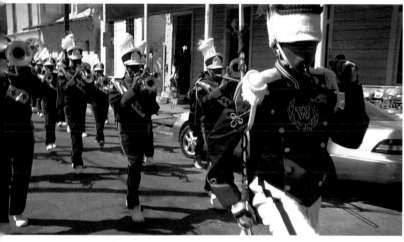
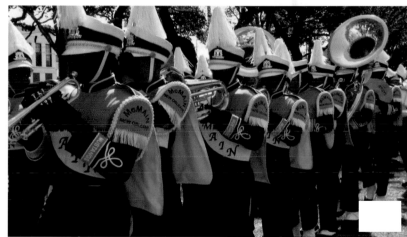
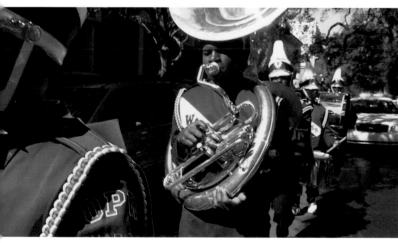

A More Perfect Union

Works on paper

2010–11

A More Perfect Union is a large-scale artwork based around online dating and the U.S. census. In progress since 2008, the work attempts to create an alternative census, based not on socio-economic fact but on socio-cultural identity.

In the summer of 2010, I joined twenty-one different online dating services and "spidered" their contents, downloading nineteen million profiles of single Americans. The profiles were sorted by zip code and analyzed for significant words. A series of national, state, and city maps (forty-three in all) show that data in various ways. Most notably, a set of prints depicts a road atlas of the United States, with the city names replaced by the word most used in that city. This lexicon of American romance, as it were, consists of more than two hundred thousand unique words, and it gives an imperfect, but extremely interesting, perspective on how Americans describe themselves in a forum where the objective is love.

website description, written 2011

Detail, *A More Perfect Union: Florida*, 2010–11.

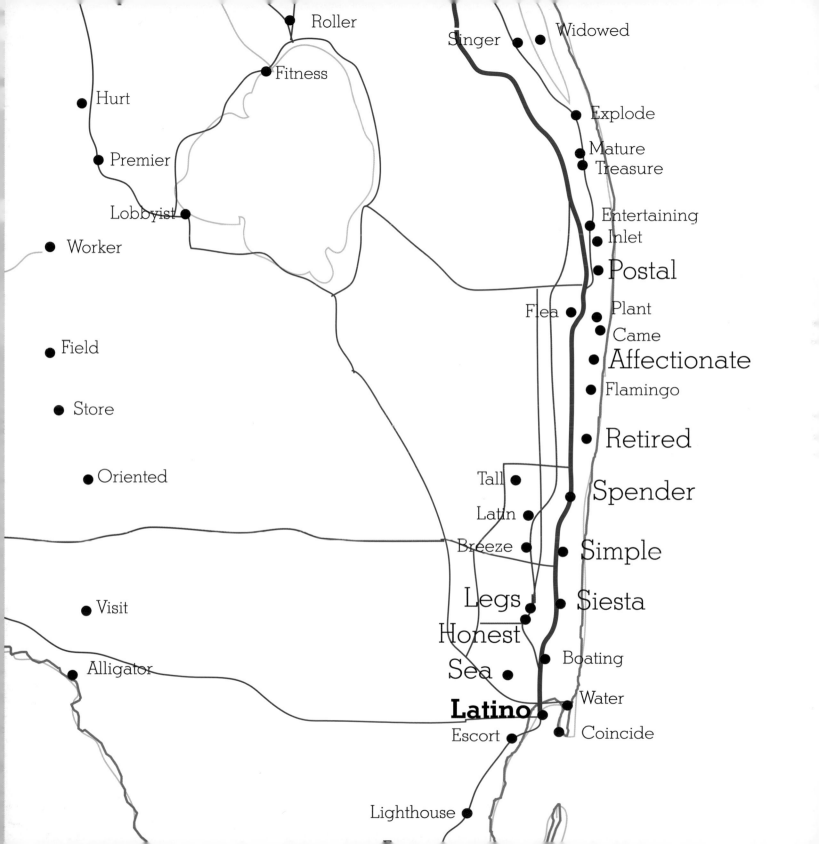

Original Title Page from *A More Perfect Union*

"You better find somebody to love." —Darby Slick

Every ten years in the United States we take a census, the purpose of which is to determine how many people live in different areas of our country, so that the makeup of the House of Representatives reflects the makeup of the nation. Along with a simple count of heads, the census asks other questions which give us insight into our income, jobs, homes, ages, and backgrounds. This information is analyzed and published by the government, telling us who we are.

But these facts and figures, interesting and useful as they may be, are not really us. What if, instead of seeing our country though the lens of income, we knew where people said they were shy? What if, instead of looking at whether we own or rent our homes, we looked at what people do on a Saturday night? What if, instead of tallying ancestry or the type of industry in which we work, we found out what kind of person we want to love?

According to a Pew Research Survey Report issued in 2006, 31% of American adults know someone who has used online dating services to find a partner. That number has surely increased in the four years since. There are literally dozens of online dating sites, catering to different ethnic groups, gender and sexual identities, age ranges, and social classes.

To join a dating site you have to, quite literally, "put yourself out there", describing yourself for the express purpose of being liked. This seemingly simple act is quite complex. You have to provide, in addition to some basic statistics, two pieces of prose: you have to say who you are, and you have to say who you want to be with. In the second piece of writing, you have to tell the truth. In the first, you have to lie.

I joined twenty-one dating sites in order to make my own census of the United States in 2010. These are my findings: a road atlas of the United States, with the names of cities, towns, and neighborhoods replaced with the words people use to describe themselves and those they want to be with.

These maps contain 20,262 unique words, based on the analysis of online dating profiles from 19,095,414 single Americans. Each word appears in the place it's used more frequently than anywhere else in the country. Enjoy.

R. Luke DuBois, New York City, January, 2011

Singles data taken from:
match.com, lavalife.com, plentyoffish.com, chemistry.com, okcupid.com, nerve.com, eharmony.com, singlesnet.com, perfectmatch.com, friendfinder.com, great-expectations.com, americansingles.com, date.com, christianmingle.com, gay.com, blacksingles.com, jdate.com, amor.com, asiafriendfinder.com, alt.com, collarme.com

Geographical data taken from:
Rand McNally, OpenStreetMap, The United States Census Bureau, The United States Postal Service.

Produced by Steven Sacks for bitforms gallery, NYC.

Printing by Supreme Digital, Brooklyn, NY.

Additional Software Development: Adam Parrish.

Additional Layout: Lesley Flanigan.

Software developed using Max/MSP/Jitter, Cycling'74, San Francisco, CA.

Thanks: Laura Blereau, Emily Bates, Lucy Ross, Tom Weinrich, Toni Dove, Kathleen Forde, Dana Karwas, Joshua Kit Clayton, and Susan Gladstone.

For my clients. With affection.

Detail, *A More Perfect Union: Salt Lake City, Denver, Atlanta, Madison*, 2010–11.

Luck

Giving

Spirituality

Gay

Dress

Energy

Lover

Arts

Tasting

Purpose

Blessed

Pride

Studied

Young

Quality

Café

Sensual

Software

Create

Architect

Intelligence

Engineer

Liberal

Fortunate Cha

Nur

Detail, *A More Perfect Union: San Francisco*, 2010–11.

Morning •

• Lives

• Growing

• Major

• Balance

Platinum •

• Blonde

Money •

Angel • •
Girly

Style

• Paramount

Acting

He

Ca

Human

Urban

Film
Feminine

Skylin

Writer

Dire

Entertainment

T

Detail, *A More Perfect Union: Los Angeles*, 2010–11.

Buddhist

Union

Mind •Loyal

• Warm

Production •

Industry

Together

Lo

Exploring

r

ashion

Vegetarian

Thousand

Heart

Connec

Relationship

r

Common

vision

Lunch

Exte

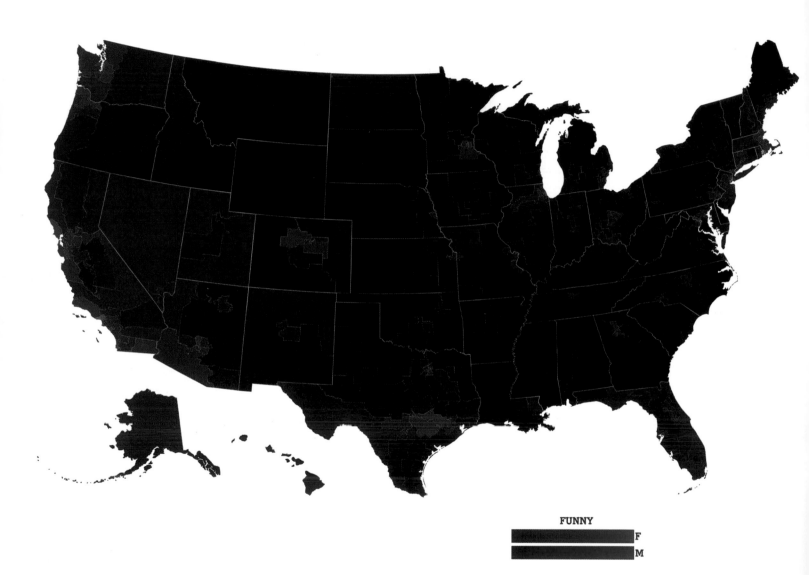

FUNNY

F

M

R. Luke Dubois — Now

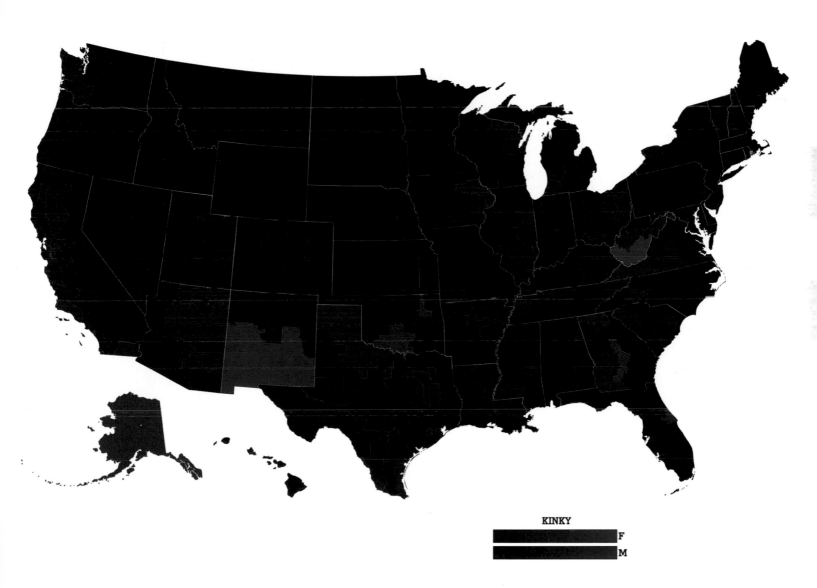

KINKY

F

M

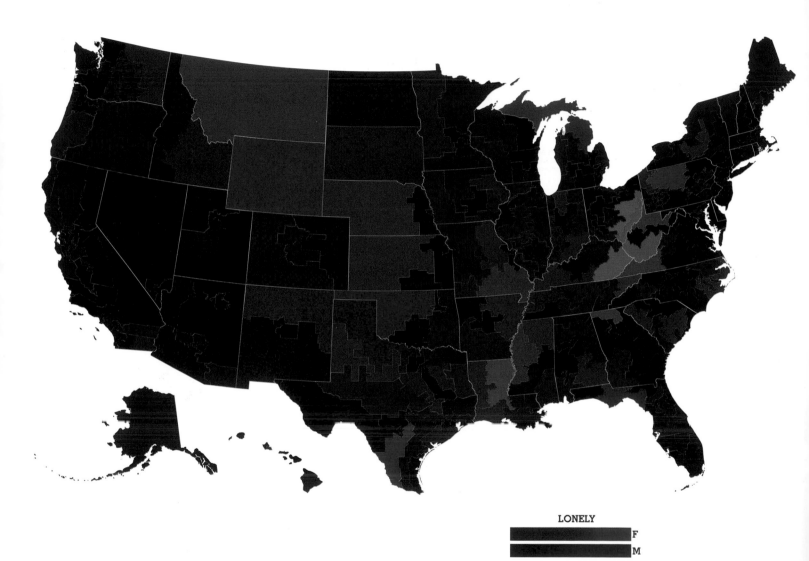

LONELY

F

M

R. Luke Dubois — Now

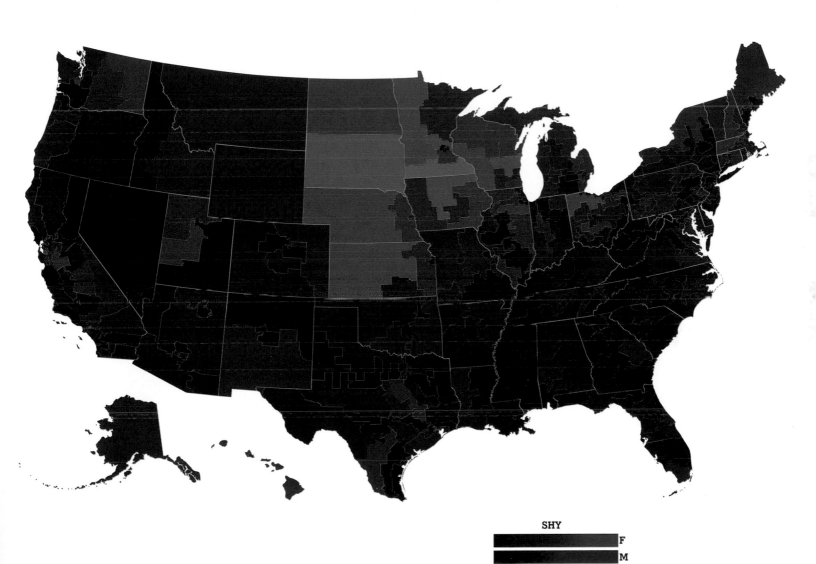

SHY

F

M

a year in mp3s

72 hours of music in 365 days

2009–10

From September 10, 2009, to September 10, 2010,
I created a piece of music every day and posted
it online, notifying followers of the project
on Facebook and through an RSS feed of its
availability. This body of composition, titled *a
year in mp3s*, documents a year in my life through
a musical trajectory. During the 365 days of
the project, I composed exactly seventy-two
hours of music, with all of the pieces available
free, online, under a Creative Commons by-nc-nd
license. Some of the pieces are quite short and
take the form of electronic sketches for longer
works; some are pop tunes that I wrote while
waiting in airports for a flight; quite a few
were done late at night using a software package
called Real-Time Cmix, which was developed
with colleagues at Columbia University in the
1990s. Some of the works are taken from live
performances with collaborators and friends, in
twenty-five cities and four countries. At the end
of the project, I published an editorial essay on
my musical journey in the *New York Times*.

 The project was inspired by a similar work
called *365 Days/365 Plays*, which was undertaken
by MacArthur- and Pulitzer award-winning
playwright Suzan-Lori Parks. Part creative
exercise, part journal, the work is a highly
personal one that serves as a documentary
of my thirty-fourth year.

liner note, written 2010

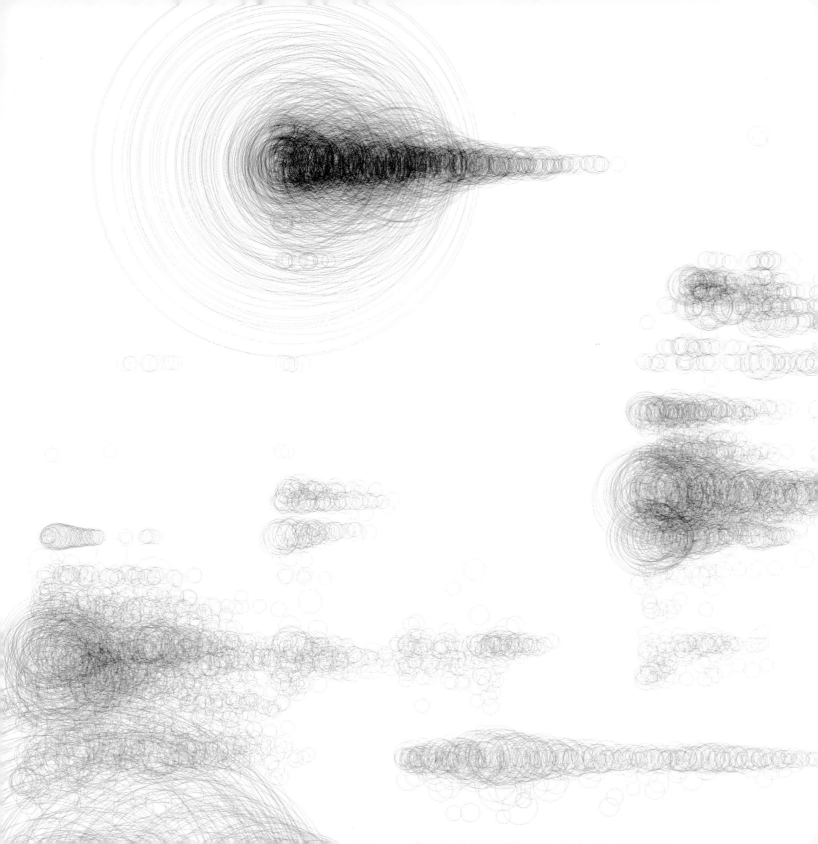

Pop Icon: Britney

Generative video with sound and custom frame

2010

Pop Icon: Britney considers the shifting meaning of icon. The original Greek word εἰκών (eikon, or image) was used to signify an object of veneration, a staple of Eastern Orthodox and Catholic religious art that depicts important figures in highly stylized and symbolic (iconic) poses and tableaux. Pop stars (so-called, pop "icons") in American culture find themselves in a similar situation; subjected to a constant mediatization, they become objects of veneration themselves. When they find themselves embroiled in scandal or subjected to gossip, the cognitive dissonance of us, their audience, is analogous to our experience of fallen angels. While this is true for many pop stars in recent years, no one fits that profile more strongly than Britney Spears.

Spears is the first pop star to exist entirely in the age of AutoTune and Photoshop. All of her vocals are digitally corrected, and she lip-syncs her live performances; as a result, there is precious little phonographic record of Spears actually singing. Instead there is merely the digitized resynthesis of her voice, perfectly in tune. Her imagery, which has been digitally cleaned, cropped, and altered, is similarly perfect, despite the fact that her media persona perfectly embodies many of the negative double standards inherent in the American objectification of famous women.

Pop Icon: Britney takes all of Spears' extant videos and singles and subjects them to a computational process that locks her eyes in place, allowing the video frame to pan around her, keeping her in a fixed position akin to an Orthodox icon. Her image is stabilized and blurred, creating a constantly shifting halo or aura around her face, reflecting back our gaze. In addition, her voice is stripped from her songs (creating an "a capella" mix) and filtered through the reverberation of the San Vitale Basilica in Ravenna, Italy, one of the most important sites of Byzantine iconography in Western Europe. The piece exists as a generative work on a medium-sized, gilded LCD frame.

artist statement, written 2010

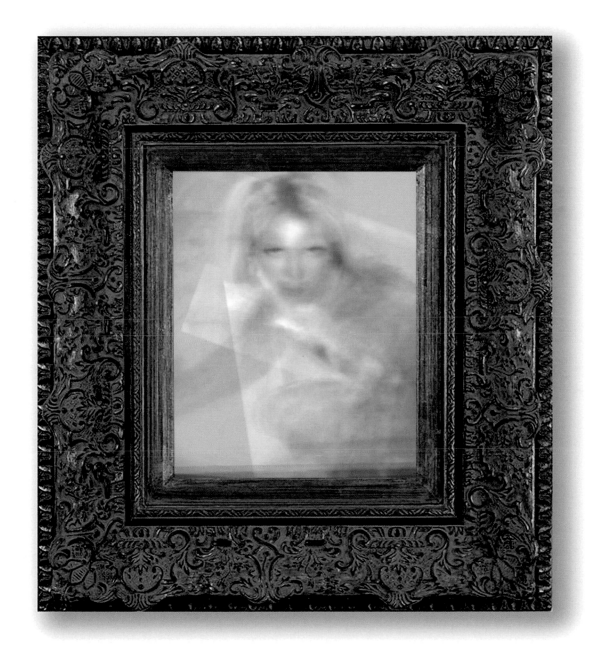

Moments of Inertia

For violin, electronics, and interactive video
2010

Moments of Inertia is a twelve-part series of works for violin, electronics, and interactive video that looks at emotional and social gesture through the metaphor of physics. The work was commissioned by Meet The Composer through their Commissioning Music/USA granting series, and it was produced by New American Radio and Performing Arts with support from the Ford Foundation, the New York State Council on the Arts, the New York City Department of Cultural Affairs, and several private foundations.

I wrote the piece for violinist Todd Reynolds, my dear friend and collaborator, whose particular performance practice revolves around the electro-acoustic technique of "live looping," in which he constructs an accompaniment for himself in real-time by generating violin passages that are sampled by the computer and repeated underneath subsequent iterations of a loop. That performance style is a game-changer for solo performers, allowing them to generate entire orchestrations without pre-recorded material. I wanted to create a work that was very much in that style, but with the added variable of extreme-time manipulation. As

a result, many of the phrases that Todd creates are sampled by custom software I wrote that stretches, programmatically reorders, and blurs the musical performance to create a cinematic accompaniment by a single live violinist.

The video for the work was created using high-speed (300fps) images of people and things in motion. The first six movements show various human-motivated actions—from skaters on an ice-skating rink to children on swing sets—at one-tenth their normal speed. The last six movements feature four human subjects in everyday conversation, focusing on their facial and physical gestures. During the performance, the violinist's pitch, amplitude, and performance style is analyzed by the computer to reanimate the footage by scrubbing it at different speeds and layering in different overlays that illustrate the optical flow characteristics of the video—in other words, how the objects in motion are actually moving.

The musical material is generated from twelve different equations that are used to determine the moment of inertia of various three-dimensional objects. *Moments of Inertia* raises

questions about how those physics equations can be reimagined in social terms. Or, how do we compute our own moment of inertia?

online description, written 2010

Original program note from the premiere of Moments of Inertia:

Moments of Inertia (2010)
R. Luke DuBois

Todd Reynolds, violin and electronics

Moments of inertia are ways of describing an object's resistance to change. To take a simple example, we can compute how much force it would take an already spinning wheel to change direction, depending on where and in what manner we apply pressure. Looked at from a certain way, this value is analogous to an object's mass; the higher its value, the more effort required to effect change upon it.

In this piece, I'm looking at the problem of calculating moments of inertia metaphorically. Rather than examining a plane and discovering how much effort it would take to bend it, or looking at a cylinder and figuring out how to reverse its direction, imagine if we could discuss this phenomenon as a social one. How much effort does it take to change your life's direction? How do you calculate the inertia of your relationships or your career? How do you determine the effort required to move across the country to be with someone you love, or move three barstools down to talk to someone you find attractive? What is the resistance value of making eye contact, or of saying you're sorry? Even in a society that prides itself on mobility, we all have our moments of inertia.

The score for this piece consists of a series of twelve short works for violin and electronics written using algorithmic techniques derived from differential equations of momentum in which moments of inertia play a role. Written with the unique talents and musical voice of Todd Reynolds in mind, the piece makes extensive use of delays and looping, with the electronic textures drawn hermetically from the sound of the violin in the performance. The video accompaniment consists of a series of high-speed video clips shot at three hundred frames per second, shuttled and manipulated by the gestures of the violin.

I'd like to thank Helen Thorington and Jo-Ann Green for their continuing faith in my work; everyone at the Issue Project Room for giving me such a wonderful space in which to perform; Anna Weisling, Lauren Rosati, and Carl Skelton, for agreeing to be subjected to the trauma of high-speed photography for this project; and Todd Reynolds, with whom I have been working for six years now, and who is almost as good a violinist as he is a friend.

Moments of Inertia is a commission of New Radio and Performing Arts, Inc., for its Turbulence. org website. It was commissioned through Meet the Composer's Commissioning Music/USA program, which is made possible by the generous support of the Mary Flagler Cary Charitable Trust, the Ford Foundation, the Francis Goelet Charitable Lead Trusts, New York City Department of Cultural Affairs, New York State Council on the Arts, the William and Flora Hewlett Foundation, and the Helen F. Whitaker Fund.

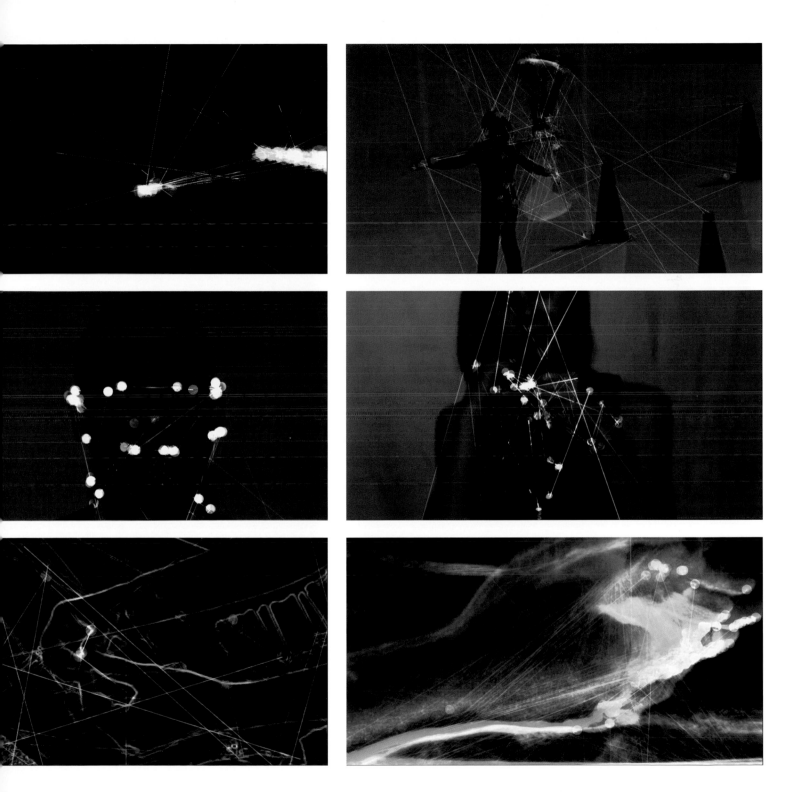

Moments of Inertia

Kiss

High-definition video

2010

Kiss is a four-minute digital video that takes fifty iconic embraces from the history of cinema and reanimates them through a nonphotorealistic rendering technique that I developed. The method analyzes the footage by looking at details that resemble the lips of the kissing actors and redrawing them with points tinted to match the colors of the original film. Because the computer schematizes lips in a mathematically abstract—and not particularly accurate—manner, all sorts of details fit that criteria, causing the software to highlight not only lips, but also hair, details in clothing, and portions of the cinematic backdrop. The software then creates a vectorization of those "points of interest" akin to a cats-cradle, connecting all the dots to create a work of moving string-art that entwines the actors performing the kiss in a new, geometric embrace of connecting lines. A deliberate misuse of computer vision, *Kiss* evokes the embrace-as-viewed, tracing the trajectory of our gaze with an abstract connectivity similar to our mirror neurons firing when we feel the romance underneath those cinematic objects. The soundtrack of the piece subjects the nondiegetic soundtrack of the kissing scenes to an auditory time-lapse effect, creating a feedback network that underscores and propels the imagery.

 As an artwork, *Kiss* is typically presented as a large wall projection.

liner note, written 2010

Kiss 89

Hard Data

String quartet and website

2009

Hard Data is a project that began as an interactive website and grew into a string quartet in six movements, commissioned by New American Radio and Performing Arts through their turbulence.org website. The online work and the subsequent string quartet performances and recording were funded with support from the New York City Department of Cultural Affairs and produced by the ISSUE Project Room and the PACE Digital Gallery.

The idea behind the work was to create an open-source "information score" of the American-led war in Iraq, taking economic, social (including casualty), political, and cultural statistics from both Iraq and the United States over the course of the war and placing them on a timeline. The timeline would then be published in a format that artists and composers could use to make new works. Along the way, I agreed to make my own sample "mapping" of the data, which became the website. By the time the website premiered in early 2009, I was asked to create another realization, this time for the MIVOS string quartet as part of the Darmstadt music festival at the ISSUE Project Room.

The string quartet version focuses on the casualty statistics of Americans and Iraqis involved or caught up in the conflict, and it sonifies the data stream in six movements, compressing the six years of war into twenty-five minutes of musical time.

The Iraq War is a conflict for which most Americans have more data than knowledge. The piece uses that data to create a musical meditation on loss, drawing influences from Western composers who have written in times of war, as well as the current Iraqi national anthem.

liner note, written 2009

Screen shot,
Hard Data, 2009.

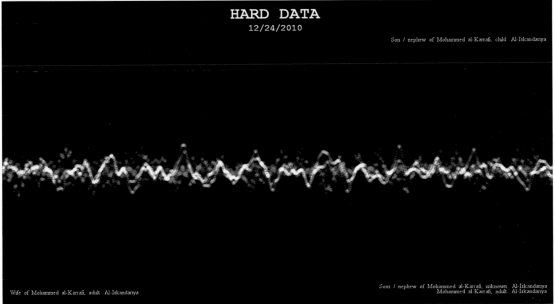

Screen shot,
Hard Data, 2011.

Original program note for Hard Data:

Hard Data
for amplified string quartet and video
in six movements
world première, june 24, 2009
ISSUE PROJECT ROOM, brooklyn, ny

I - men
II - children
III - soldiers
IV - refugees
V - women
VI - missing

Data taken from:
The Brookings Institute, The Iraq Coalition
Casualty Count, Iraq Body Count, The U.S. Dept.
of State Bureau of Near Eastern Affairs, The
Joint Economic Committee of the U.S. Congress,
Iraq Today, The New York Times

Six years have gone by since the United States
invaded Iraq, in March of 2003. The decision
to invade, and the rationale behind it, has
emerged as a defining event in the relationship
between the United States and the rest of the
world, and will be read by history as a watershed
moment in the geopolitics of the 21st century.
To the people of Iraq, the invasion has brought
alternating streams of trauma, displacement,
fear, anger, confusion, and – in liminal spaces
between and among the wreckage of their country
– faint and growing shimmers of hope. To people
here in the United States, the Iraq war has
been, depending on your frame of reference, a
necessary and just response to the provocations
of the regime of Saddam Hussein, an unnecessary
and wasteful "war of choice" that has bankrupted
our moral authority in the world and damaged
our future security and stability, or a tragic
event that has claimed the life of a loved one,
neighbor, classmate, friend, or acquaintance.
For many Americans, all three are true, to some
degree. But for many of us, the Iraq war is a
vague and distant worry, delivered to us through
mass media, and embodied most strongly by a
stream of numbers.

These numbers are always there, following
us, and they seem to be haunted. Living under a
24-hour news cycle, wired to the overwhelming
commentary of citizen journalism within a
culture obsessed with statistics, has made the
Iraq war the first conflict in which, for most
of us, we possess more data than knowledge. This
is partly a shortcoming of the mediatized Iraq
presented to us in video, sound, and images,
which gives us a monolithically stark and
necessarily limited view of a human conflict
that, whether issued as soundbite or photo
essay, we shy away from. But the real reason for
our abstract understanding of this conflict is
our willingness to seek solace in facts. Our
volunteer military (in which only a fraction
of our society participates) fights overseas
against insurgent elements (in a country few
of us have visited) in the hopes of stabilizing
a country (with which we have little common
cultural currency). This is not a fact, but a
complex and devastating concept, and many of
us find our mind's eye strained; so instead
of shock as we watch news reports, read an
entire spectrum of press coverage, and consume
anecdotal summaries, we learn the numbers of war.
We anesthetize ourselves with hard data.

If confusing information with experience is a
vice then our country is guilty. I have spent the
last six months looking at the facts, figures,

statistics, and documents of the Iraq war. I know three veterans of the Iraq conflict personally, none of whom are inclined to look charitably on the fact that we prefer to understand this war largely in information space and fret about it far more in terms of fiscal and moral damage than human cost. Americans like to know numbers. 50 states. 300 million people. I am guilty, too.

Ian MacKaye, of the band Fugazi, once wrote that we need an instrument / to find out, how loss could weigh. This couplet seemed prophetic to me in high school, as I related to the militant anti-capitalism and dense, sad anger of its double message. What seemed so important to me about that lyric then has been forgotten, but the lyric now seems incredibly to the point. The Iraq War, delivered to most of us as a real-time stream of data, is all about loss. We have lost lives; we have lost fiscal certitude; we have lost our moral compass; and we have lost a vital element of our national integrity thanks to the partisanship of those who have scored political points over this war. In order for us to make sense of this loss, it has to resonate beyond facts and figures, because the hard data we look at is "hard" in that other way. Not reliable, but unbearable. We need that instrument. Badly.

Which brings me to this project. A work-in-progress if there ever was one.

The composer Iannis Xenakis had a unique gift for creating kinetic masses of sound out of statistical processes. More important here (and the reason why I mention him), his experiences as a partisan in the Second World War and his training as an architect under Le Corbusier gave him a unique competence to compose music that sounded like war. Aware of the acute difference between strategy and tactics, Xenakis created music that perfectly evoked the dialectic of a situation that, though well-planned and executed on a macro-scale (strategic), was incomprehensible and chaotic at the event level (tactical). Furthermore, Xenakis' interdisciplinary acumen as an architect/composer led him to develop a theory of 'meta-art', based around the idea that any medium can serve to realize the same artistic expression.

Hard Data is a data-mining and sonification project based around data from the American military actions in Iraq. The aim of the piece is to create an open-source score which can be realized by any number of people in any medium. The version presented here tonight is an arrangement of some of this information into six movements for amplified string quartet with video projection. Conceptually, it riffs off of Xenakis understanding of formalized music, though musically it mixes in more than a little Stravinsky, Messiaen, and Crumb, three composers who wrote in tempore belli. Most importantly, however, this realization is grounded in an algorithmic realization of the source data through the filter of that country's current national anthem, Mohammad Flaifel's setting of Ibrahim Touqan's 1934 poem *Mawtini*.

Hard Data was a 2009 commission of New American Radio and Performing Arts, Inc. for its Turbulence web site (turbulence.org). This was made possible with funding from the New York City Department of Cultural Affairs. I'd like to thank Helen Thorington and Jo-Ann Green for their faith in the project; the Mivos String Quartet for premiering the work; Toni Dove, Michael Joaquin Grey, Laura Blereau, and Susan Gladstone; Zach Layton and Nick Hallett for programming the piece as part of their Darmstadt "Institute"; the Issue Project Room and Suzanne Fiol, for giving me such a great space in which to perform.

Hindsight Is Always 20/20

Public sculpture and print series

2008

Commissioned for the 2008 Democratic National Convention, *Hindsight Is Always 20/20* is a work I developed using data from the American Presidency Project at the University of California, Santa Barbara. The piece consists of forty-one Snellen-style eye charts, plus title and essay, showing the top sixty-six words of each American president's State of the Union addresses, from George Washington through George W. Bush. The charts reflect the themes, ideals, and topics of their age, allowing viewers to experience American history through political rhetoric.

The piece has been touring nationwide since 2008 in two versions. The first is a large-scale public sculpture of forty-three steel-and-aluminum light boxes illuminated with fluorescent tubes backlighting a Lexan screen containing each president's eye chart. The sculpture has toured from Denver to the National Constitution Center in Philadelphia, the Scottsdale Museum of Contemporary Art in Arizona, the PULSE Art Fair in New York City, the Second Street Gallery and Monticello in Charlottesville, Virginia, and the DUMBO Arts Festival, in Brooklyn, New York. The light boxes are built to Snellen scale, allowing viewers to test their vision against that of each president.

The second version is a set of forty-three letterpress prints at two-thirds the size of the light boxes. The set was first shown in a solo exhibition at the Weisman Art Museum in Minneapolis during the 2008 Republican National Convention, and it has been displayed at museums and galleries around the country.

The project was envisioned as a way to emphasize the State of the Union address as a significant aspect of the power relationship between the executive and legislative branches of the U.S. government, as well as a comment on the metaphor of vision in evaluating leadership throughout history.

liner note, updated online, 2013

Hindsight Is Always 20/20, 2008
(installation, DUMBO, Brooklyn, 2012).

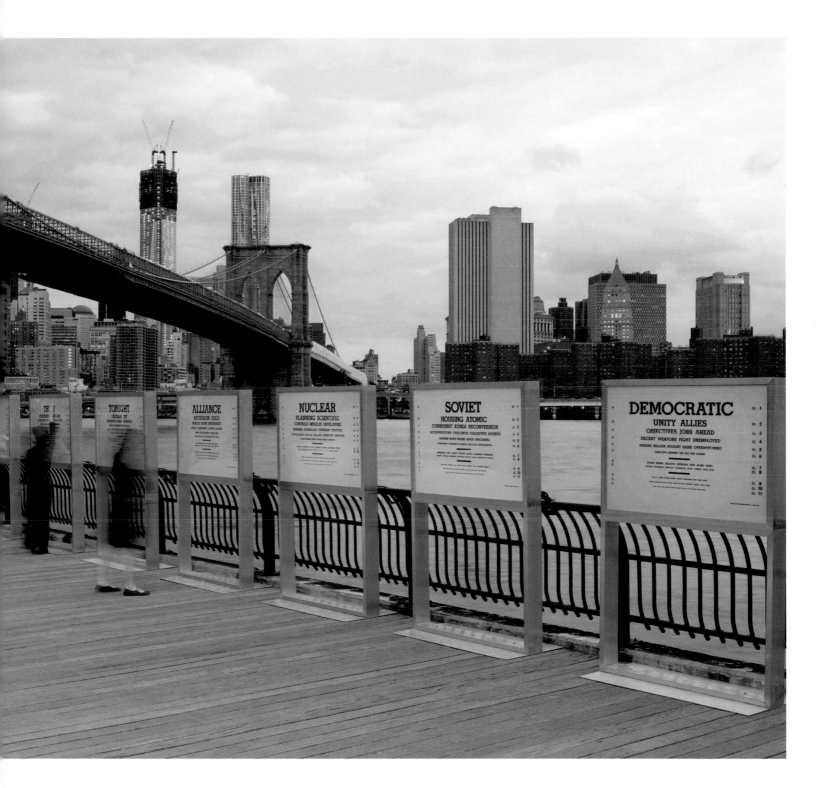

20/200	# HINDSIGHT	200 FT. / 61 M **1**
20/100	## IS ALWAYS 20/20	100 FT. / 30.5 M **2**
20/70	### R. LUKE DUBOIS	70 FT. / 21.3 M **3**
20/50	DATA FROM THE AMERICAN PRESIDENCY PROJECT	50 FT. / 15.2 M **4**
20/40	UNIVERSITY OF CALIFORNIA, SANTA BARBARA	40 FT. / 12.2 M **5**
20/30	PRODUCED BY DANA KARWAS FOR BITFORMS GALLERY, NYC	30 FT. / 9.14 M **6**

▬▬▬▬▬▬

GRAPHIC DESIGN BY ROGERBOVA.COM, NYC

LETTERPRESS BY COEUR NOIR, BROOKLYN, NY

| 20/25 | | 25 FT. / 7.62 M **7** |
| 20/20 | | 20 FT. / 6.10 M **8** |

▬▬▬▬▬▬

SOFTWARE DEVELOPED USING MAX/MSP/JITTER, CYCLING '74, SAN FRANCISCO, CA

FOR MY FATHER, ROGER

20/15		15 FT. / 4.57 M **9**
20/13		13 FT. / 3.96 M **10**
20/10		10 FT. / 3.05 M **11**

R. LUKE DUBOIS / 1975–

| $\frac{20}{200}$ | THE STATE OF THE UNION ADDRESS IS OUR ONLY CONSTITUTIONALLY-MANDATED PIECE OF POLITICAL THEATER | 200 FT. / 61 M | **1** |

EVERY YEAR THE PRESIDENT DELIVERS AN ADDRESS IN WRITING OR IN PERSON TO CONGRESS

| $\frac{20}{100}$ | THIS HAS TWO IMPORTANT PURPOSES, ONE EXPLICIT THE OTHER IMPLICIT | 100 FT. / 30.5 M | **2** |

| $\frac{20}{70}$ | THE EXPLICIT REASON FOR THE ADDRESS IS FOR THE PRESIDENT TO FORMALLY SUMMARIZE THE CHALLENGES FACING THE NATION | 70 FT. / 21.3 M | **3** |

| | THIS IS THE LITERAL "STATE" OF THE UNION | | |

| $\frac{20}{50}$ | THE PRESIDENT THEN OUTLINES POLICIES IN RESPONSE AND A LEGISLATIVE AGENDA IS RECOMMENDED FOR CONGRESS TO CONSIDER | 50 FT. / 15.2 M | **4** |

| $\frac{20}{40}$ | ONE COULD ARGUE HOWEVER THAT THE IMPLICIT ROLE OF THE ADDRESS IS FAR MORE IMPORTANT | 40 FT. / 12.2 M | **5** |

| $\frac{20}{30}$ | BY REQUIRING THAT THE PRESIDENT REPORT "FROM TIME TO TIME" TO CONGRESS AS ARTICLE II SECTION 3 OF THE CONSTITUTION REQUIRES | 30 FT. / 9.14 M | **6** |

| $\frac{20}{25}$ | THE FRAMERS OF THE CONSTITUTION INSTITUTED A FORMAL PRACTICE DESIGNED TO DEMONSTRATE THAT THE PRESIDENT MUST MAKE HIMSELF | 25 FT. / 7.62 M | **7** |
| $\frac{20}{20}$ | REGULARLY ACCOUNTABLE TO THE DEMOCRATICALLY ELECTED LEGISLATURE | 20 FT. / 6.10 M | **8** |

AS SUCH THE ADDRESS REMINDS US THAT IN OUR REPUBLIC CONGRESS IS SOVEREIGN

$\frac{20}{15}$	WE THE PEOPLE	15 FT. / 4.57 M	**9**
$\frac{20}{13}$	NOT	13 FT. / 3.96 M	**10**
$\frac{20}{10}$	I THE PRESIDENT	10 FT. / 3.05 M	**11**

R. LUKE DUBOIS / 1975-

GENTLEMEN

PROVISION FELLOW

INFORMATION INDIANS PARTICULAR

LAID MILITIA OUGHT OBJECT

WHETHER CIRCUMSTANCES CONSTITUTION OBJECTS REGARD

TRIBES HAPPINESS SATISFACTION ESTABLISHMENT PROVISIONS WELFARE

SITUATION EXECUTION SUCCESS FOUND ORDER REQUISITE AFFORD

TERMS VALUABLE PRINCIPLES WISH AFFAIRS PLACED PLAN RESPECT

POST OFFICE DELIBERATIONS EXPENSE OCCASION SAFETY CONSIDERATIONS COMMUNITY SECURITY

SPIRIT ADD COOPERATION DIRECTED ESTIMATE NECESSITY TRANQUILLITY CREDIT CONSTITUENTS BLESSINGS

ESSENTIAL PARTICULARLY ARRANGEMENTS WESTERN TRUST CONFIDENCE LEGISLATURE EQUAL THOUGH ABLE ACTS

Left column markers (top to bottom):
$\frac{20}{200}$, $\frac{20}{100}$, $\frac{20}{70}$, $\frac{20}{50}$, $\frac{20}{40}$, $\frac{20}{30}$, $\frac{20}{25}$, $\frac{20}{20}$, $\frac{20}{15}$, $\frac{20}{13}$, $\frac{20}{10}$

Right column markers (top to bottom):
$\frac{200 \text{ ft.}}{61 \text{ m}}$ 1, $\frac{100 \text{ ft.}}{30.5 \text{ m}}$ 2, $\frac{70 \text{ ft.}}{21.3 \text{ m}}$ 3, $\frac{50 \text{ ft.}}{15.2 \text{ m}}$ 4, $\frac{40 \text{ ft.}}{12.2 \text{ m}}$ 5, $\frac{30 \text{ ft.}}{9.14 \text{ m}}$ 6, $\frac{25 \text{ ft.}}{7.62 \text{ m}}$ 7, $\frac{20 \text{ ft.}}{6.10 \text{ m}}$ 8, $\frac{15 \text{ ft.}}{4.57 \text{ m}}$ 9, $\frac{13 \text{ ft.}}{3.96 \text{ m}}$ 10, $\frac{10 \text{ ft.}}{3.05 \text{ m}}$ 11

GEORGE WASHINGTON / 1789-1797

LIMITS

SUM SOON

FRIENDSHIP HARBORS FRIENDLY

THOUGHT CALL MISSISSIPPI MEETING

MEASURE SUFFICIENT EXPENSES PARTS RECEIPTS

PORT MEDITERRANEAN ENABLED DISCHARGE USEFUL BELLIGERENT

━━━━━━━━

IMMEDIATELY ARMED PERMITTED DEMANDS EXERCISE THINGS NOR

EMPLOYED MOMENT NEARLY AUTHORIZED QUARTER WATERS FUNDED EARLY

━━━━━━━━

REMAIN ENTERPRISE INTERNAL DEEMED AID PORTION NAVAL PROVIDING PURPOSES

PRODUCE ORLEANS BECOME INDEED NEUTRAL COMMITTED BEYOND FORM CONTEMPLATED 1"

THINE MAINTAIN RESPECTING TIMES ORDINARY LOUISIANA CONVENTION RECEIVE REGULAR PROPOSED FUNCTIONS

Left	Line	Right
20/200	LIMITS	200 FT / 61 M — 1
20/100	SUM SOON	100 FT / 30.5 M — 2
20/70	FRIENDSHIP HARBORS FRIENDLY	70 FT / 21.3 M — 3
20/50	THOUGHT CALL MISSISSIPPI MEETING	50 FT / 15.2 M — 4
20/40	MEASURE SUFFICIENT EXPENSES PARTS RECEIPTS	40 FT / 12.2 M — 5
20/30	PORT MEDITERRANEAN ENABLED DISCHARGE USEFUL BELLIGERENT	30 FT / 9.14 M — 6
20/25	IMMEDIATELY ARMED PERMITTED DEMANDS EXERCISE THINGS NOR	25 FT / 7.62 M — 7
20/20	EMPLOYED MOMENT NEARLY AUTHORIZED QUARTER WATERS FUNDED EARLY	20 FT / 6.10 M — 8
20/15	REMAIN ENTERPRISE INTERNAL DEEMED AID PORTION NAVAL PROVIDING PURPOSES	15 FT / 4.57 M — 9
20/13	PRODUCE ORLEANS BECOME INDEED NEUTRAL COMMITTED BEYOND FORM CONTEMPLATED 1"	13 FT / 3.96 M — 10
20/10	THINE MAINTAIN RESPECTING TIMES ORDINARY LOUISIANA CONVENTION RECEIVE REGULAR PROPOSED FUNCTIONS	10 FT / 3.05 M — 11

THOMAS JEFFERSON / 1801-1809

TEXAS

TEXAS

CIRCULATION SOUND

THEREBY FACT DISTANT

ADVANCE MEDIUM ISSUES ANNEXATION

CORRESPONDENCE ENTIRELY REFERENCE ALTOGETHER GOLD

SILVER BILLS FACILITIES DESTINED MARKET EXPEDIENT

EXCHEQUER RESORT MISTER SLAVE URGE WORTHY FAILED

WISE INCIDENT FURNISHING ALMOST EVERYWHERE THREATENED OPERATE ENTER

FIND EXISTS CHIEF HEREWITH SENTIMENT PLEASURE HUMANITY EFFORT REFER

NUMEROUS REDEMPTION ADVANCING GOODS WEALTH ANSWERED BECOMES SUBMIT ARISE CULTIVATE

MANIFESTED FAIR EXPRESS GROWING ENGAGEMENTS RUN APART EIGHT DESIGNED ABOVE STOCKS

JOHN TYLER / 1841–1845

Left markers (top to bottom): 20/200, 20/100, 20/70, 20/50, 20/40, 20/30, 20/25, 20/20, 20/15, 20/13, 20/10

Right markers (top to bottom): 200 ft / 61 m — 1, 100 ft / 30.5 m — 2, 70 ft / 21.3 m — 3, 50 ft / 15.2 m — 4, 40 ft / 12.2 m — 5, 30 ft / 9.14 m — 6, 25 ft / 7.62 m — 7, 20 ft / 6.10 m — 8, 15 ft / 4.57 m — 9, 13 ft / 3.96 m — 10, 10 ft / 3.05 m — 11

OREGON

CALIFORNIA 30TH

PACIFIC RATES STEAMERS

IMPOSED JULY MARCH FORCES

INCLUDING FAVORED REDRESS NORTH TERRITORIES

BECAUSE APRIL RIO TERRITORIAL REDUCED JUNE

WEALTH HOSTILITIES DERIVED CLASSES MILES GRANDE LOAN

MONTH EUROPEAN COMPROMISE PAREDES DECEMBER IMPORTED HOME HANDS

OFFERED CONTINENT MONTHS POSITION COLLECTED COMMISSIONER REVOLUTION CIVIL TOGETHER

HERSELF DECLARED PERSONS AUGUST ACCORDING SAID PROBABLY HOLD PER RETURN

LARGER MAJORITY PROTECTIVE DID HOUSES CAPITAL LABOR SALE INHABITANTS JOINT PROTECT

JAMES KNOX POLK / 1845–1849

Left markers (top to bottom): 20/200, 20/100, 20/70, 20/50, 20/40, 20/30, 20/25, 20/20, 20/15, 20/13, 20/10

Right markers (top to bottom): 200 ft / 61 m — 1, 100 ft / 30.5 m — 2, 70 ft / 21.3 m — 3, 50 ft / 15.2 m — 4, 40 ft / 12.2 m — 5, 30 ft / 9.14 m — 6, 25 ft / 7.62 m — 7, 20 ft / 6.10 m — 8, 15 ft / 4.57 m — 9, 13 ft / 3.96 m — 10, 10 ft / 3.05 m — 11

R. Luke Dubois — Now

EMPIRE

ISLANDS GERMAN

RESPECTFULLY ISTHMUS PROPERLY

FRANKFURT ACROSS MINERAL POSTAGE

POSTERITY DIPLOMATIC EXPEDITION D'AFFAIRES LETTER

SAN GRANADA PANAMA INTERPOSE NICARAGUA CONSTRUCTED

———

DEFICIT STRICT ENCOURAGEMENT AGRICULTURAL STUDY MINING LENGTH

CARGOES CHARGES ENVOY PLENIPOTENTIARY SHORTLY BELONGING DENMARK INSTRUCTED

———

ACCREDITED PRUSSIA BERLIN LEGATION TRANSFERRED LAWFUL HIMSELF INJUNCTIONS SOIL

SUGGEST PROSPECT STAND UNSUCCESSFUL PORTUGAL SUFFICIENTLY OPENING FAITHFUL OBSTACLES LATEST

OBTAINING EXAMINE PROBABLE DISPOSED NEGOTIATED LETTERS PROCEED COMPOSED NAME GUARANTIES EXPLORATION

Left scale (top to bottom): 20/200, 20/100, 20/70, 20/50, 20/40, 20/30, 20/25, 20/20, 20/15, 20/13, 20/10

Right scale:
1 — 200 FT. / 61 M
2 — 100 FT. / 30.5 M
3 — 70 FT. / 21.3 M
4 — 50 FT. / 15.2 M
5 — 40 FT. / 12.2 M
6 — 30 FT. / 9.14 M
7 — 25 FT. / 7.62 M
8 — 20 FT. / 6.10 M
9 — 15 FT. / 4.57 M
10 — 13 FT. / 3.96 M
11 — 10 FT. / 3.05 M

ZACHARY TAYLOR / 1849-1850

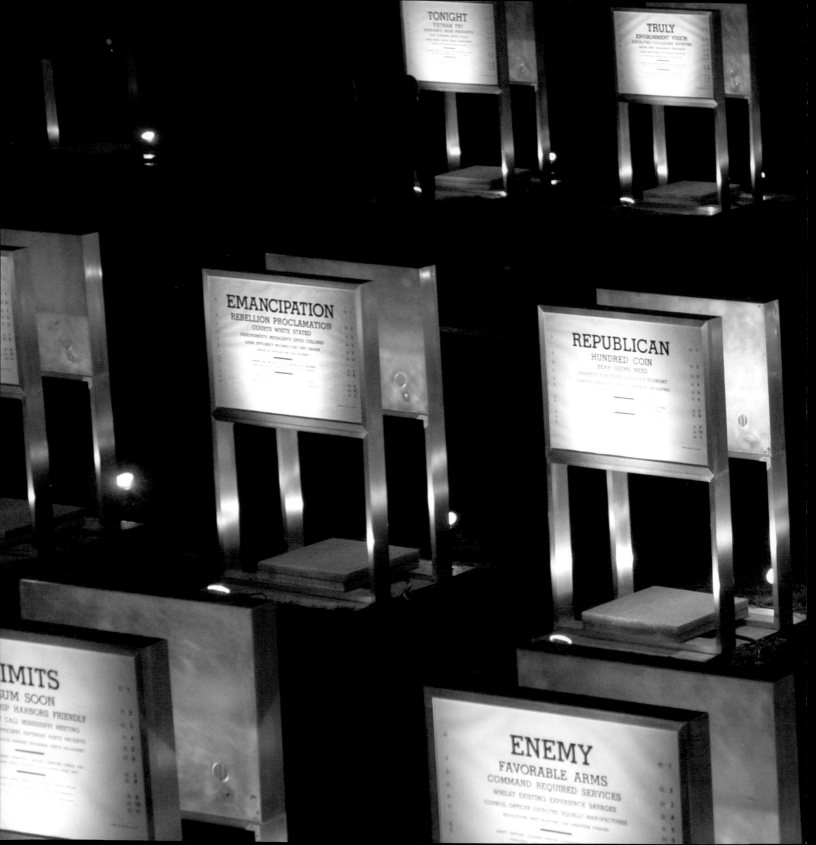

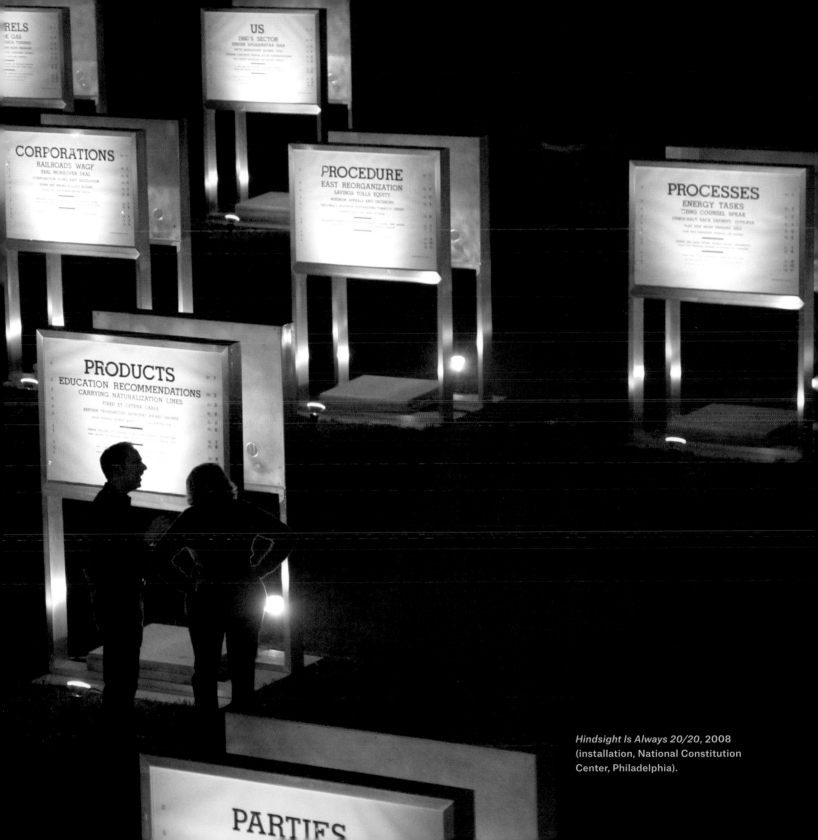

Hindsight Is Always 20/20, 2008
(installation, National Constitution
Center, Philadelphia).

CENTRAL

SOCIAL KANSAS

COMPANY INTERNATIONAL SUGGESTIONS

COMPACT STATUTE PASSING EXEMPT

DOMAIN VIOLENCE SOUTHERN ENJOYMENT LEGAL

AGITATION SECTIONAL PEACEFUL TRANSIT MERELY SECTIONS

———

ENACTMENT ENTERED RESTRICTIONS MAGNITUDE NATURAL PRACTICAL INADEQUATE

EQUALITY ALIKE CITIES PENDING SOUGHT PATRIOTIC MIND MORAL

PECULIAR PRETENSIONS CONSUL REGARDING THEREIN CONFEDERATION VOICE RESERVED DETAILS

PERFORMED MEMBERS WHOLLY INVOLVED RECIPROCAL ASSUMED RELATIVE SOVEREIGNTY DECLARATION MISSOURI

APPARENT DATE OCCASIONAL SURRENDER OPPORTUNITY ORGANIC INSTANCES MODIFICATIONS ASSENT ACTIVE REVOLUTIONARY

Left markers (top to bottom): 20/200, 20/100, 20/70, 20/50, 20/40, 20/30, 20/25, 20/20, 20/15, 20/13, 20/10

Right markers: 200 ft / 61 w — 1; 100 ft / 30.5 w — 2; 70 ft / 21.3 w — 3; 50 ft / 15.2 w — 4; 40 ft / 12.2 w — 5; 30 ft / 9.14 w — 6; 25 ft / 7.62 w — 7; 20 ft / 6.10 w — 8; 15 ft / 4.57 w — 9; 13 ft / 3.96 w — 10; 10 ft / 3.05 w — 11

FRANKLIN PIERCE, SR. / 1853-1857

SLAVERY

ELECTION HONDURAS

SLAVES ADMISSION VOTE

GOVERNOR IMMEDIATE UTAH ROUTE

FAIR DANGEROUS ACTUAL HISTORY EMPLOY

PROVE IMPOSSIBLE PASS REMAINING COMMENCEMENT AFRICAN

———

NOTWITHSTANDING LEAST SOVEREIGNTY PROPORTION SINGLE BOUND CONSENT

UNLESS PROVIDE FINALLY BESIDES CHINA ASCERTAINED PASSAGE LAWLESS

REVOLUTIONARY REMEDY PROCEED HEREAFTER MEMBERS DELEGATES RECOGNIZED AFRICA FAIRLY

VAIN DATE RATIFIED AMENDMENT RECOMMENDATION CHINESE POWERFUL ENTITLED SUPREME INJURY

AFTERWARDS DIRECTLY ADJUSTED ROUTES OUTRAGES DEFICIENCY PROCEEDINGS SURELY WRONGS KEEP EXISTENCE

Left markers (top to bottom): 20/200, 20/100, 20/70, 20/50, 20/40, 20/30, 20/25, 20/20, 20/15, 20/13, 20/10

Right markers: 200 ft / 61 w — 1; 100 ft / 30.5 w — 2; 70 ft / 21.3 w — 3; 50 ft / 15.2 w — 4; 40 ft / 12.2 w — 5; 30 ft / 9.14 w — 6; 25 ft / 7.62 w — 7; 20 ft / 6.10 w — 8; 15 ft / 4.57 w — 9; 13 ft / 3.96 w — 10; 10 ft / 3.05 w — 11

JAMES BUCHANAN / 1857-1861

EMANCIPATION

200 FT. / 61 M **1**

REBELLION PROCLAMATION

20/100 100 FT. / 30.5 M **2**

COURTS WHITE STATED

20/70 70 FT. / 21.3 M **3**

DISBURSMENTS INSURGENTS GIVES COLORED

20/50 50 FT. / 15.2 M **4**

LOYAL EFFICIENCY INSURRECTION CENT REGION

20/40 40 FT. / 12.2 M **5**

JUDICIAL LET INSURGENT SAY CASH BEGINNING

20/30 30 FT. / 9.14 M **6**

FOREVER ASK KENTUCKY SOURCES NEITHER HOW LABORERS

20/25 25 FT. / 7.62 M **7**

OPEN CLASS MARYLAND CERTAINLY POSTAL SAVE ABUNDANT TEMPORARY

20/20 20 FT. / 6.10 M **8**

BLOCKADE SUBMIT KNOW SUPPRESSION WANT VIRGINIA PENSIONS FRIENDS SEVEN

20/15 15 FT. / 4.57 M **9**

MAINTAINED COMPLETE TELEGRAPH BONDS PENSIONERS DISLOYAL EXPEDIENCY RESTORATION TENNESSEE WHY

20/13 13 FT. / 3.96 M **10**

VITAL COME PLACES GO SHOWN TOTAL SHOWS SALES LARGELY PERSON MODE

20/10 10 FT. / 3.05 M **11**

ABRAHAM LINCOLN / 1861-1865

VETERANS

FLOOD PROHIBITION

AIR LEAGUE PROJECT

ARMAMENTS WATERWAYS CONTINUING PROPOSALS

MUSCLE SHOALS RESEARCH MODERATE CONSOLIDATIONS

INCREASES DEPRESSION DEPENDENTS STABILITY ACREAGE EARNER

ASSOCIATIONS OPPOSED ADMINISTERED GOING CROP NITRATES FORWARD

COMMODITIES RELIEVED CHARITY DIMINISHING COLORADO AVIATION PUTTING SOLELY

UNDERTAKING HIGHWAYS PURCHASING INLAND EARNERS GRANTING SOMEWHAT ATTEMPTING STRUCTURE

EVERYONE SUPPORTED SPIRITUAL ERA AIRCRAFT FUNCTION ACCRUE ENGINEERING SCIENTIFIC GOES

RADIO BOARDS SOLICITOUS SERVED MEMORIAL ADHERE EVERYBODY LAWRENCE FAST REGULATORY MEANTIME

20/200	200 ft. / 6.1 w	1
20/100	100 ft. / 30.5 w	2
20/70	70 ft. / 21.3 w	3
20/50	50 ft. / 15.2 w	4
20/40	40 ft. / 12.2 w	5
20/30	30 ft. / 9.14 w	6
20/25	25 ft. / 7.62 w	7
20/20	20 ft. / 6.10 w	8
20/15	15 ft. / 4.57 w	9
20/13	13 ft. / 3.96 w	10
20/10	10 ft. / 3.05 w	11

CALVIN COOLIDGE, JR. / 1923-1929

UNEMPLOYMENT

RECOVERY MAJOR

DISTRESS AFFECTED OFFICIALS

DIRECTIONS STRUCTURE WIDE RECONSTRUCTION

STRENGTHENING FAILURES CRISIS VOLUNTARY DROUGHT

VOLUME FOUNDATIONS CONTRIBUTION SECURITIES VALUES ITEMS

WATERWAY HIGHWAY SYSTEMS ELECTRICAL INITIATIVE EMERGENCIES SPIRITUAL

INDICATED REVIEW AVIATION APPROXIMATELY ACTIVITY ORGANIZATIONS EXHAUSTIVE TYPES

WINTER ANTITRUST SOLUTIONS COMMISSIONS INQUIRY REVISED STANDARDS CONSUMPTION SUFFERING

BUYING OUTSIDE PRACTICES ASSURE STIMULATE LAY INDICATE DEPRESSIONS FALL PROTECTED

HOARDING SHOCKS SPREAD CONFRONTED ELIMINATE ENTRY LONDON HAITI PROGRAMS MANUFACTURING FINANCES

20/200	200 ft. / 6.1 w	1
20/100	100 ft. / 30.5 w	2
20/70	70 ft. / 21.3 w	3
20/50	50 ft. / 15.2 w	4
20/40	40 ft. / 12.2 w	5
20/30	30 ft. / 9.14 w	6
20/25	25 ft. / 7.62 w	7
20/20	20 ft. / 6.10 w	8
20/15	15 ft. / 4.57 w	9
20/13	13 ft. / 3.96 w	10
20/10	10 ft. / 3.05 w	11

HERBERT CLARK HOOVER / 1929-1933

DEMOCRATIC

UNITY ALLIES

OBJECTIVES JOBS AHEAD

DECENT WEAPONS FIGHT UNEMPLOYED

NURSES BILLION FOUGHT RAISE OVERWHELMING

OBJECTIVE LEARNED YES JOB WIN PLANES

—————

HOURS BEHIND RELIGION OFFENSIVE AXIS ALLIED SPEED

CIVILIAN THOUSANDS AMERICA'S DOMINATION FRONT COMBAT LEVEL GOAL

—————

FOLLOW TANKS FORGET INTEND DEFEAT PEACETIME SONS CHILD HARD

ATTAIN LIBERATION FACED SUCCEED BRAVE DICTATORS ENDURING TYRANNY GOALS HITLER

NAZIS STRATEGY NAZI MANPOWER GERMANS PERCENT BALANCED TOOLS MACHINE ANCIENT RISING

FRANKLIN DELANO ROOSEVELT / 1933-1945

Left column (visual acuity):
20/200, 20/100, 20/70, 20/50, 20/40, 20/30, 20/25, 20/20, 20/15, 20/13, 20/10

Right column (distances):
200 FT / 61 M — 1
100 FT / 30.5 M — 2
70 FT / 21.3 M — 3
50 FT / 15.2 M — 4
40 FT / 12.2 M — 5
30 FT / 9.14 M — 6
25 FT / 7.62 M — 7
20 FT / 6.10 M — 8
15 FT / 4.57 M — 9
13 FT / 3.96 M — 10
10 FT / 3.05 M — 11

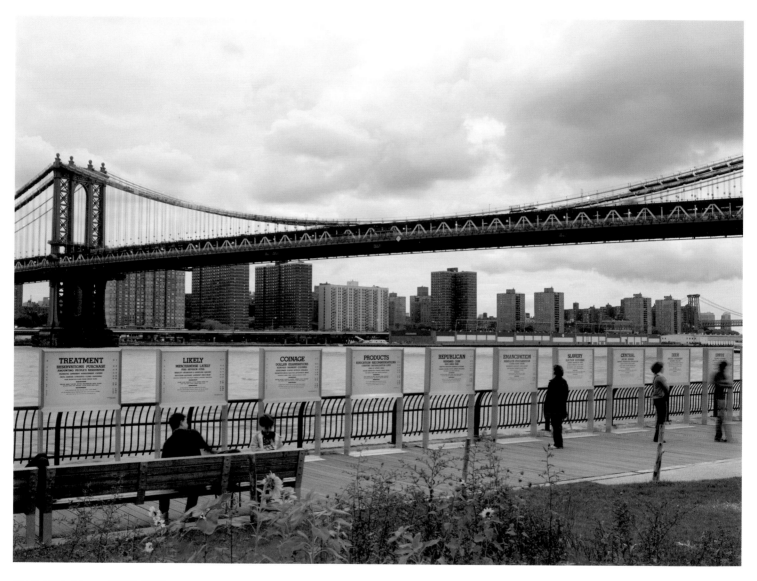

Hindsight Is Always 20/20, 2008
(installation, DUMBO, Brooklyn, 2012).

R. Luke Dubois — Now

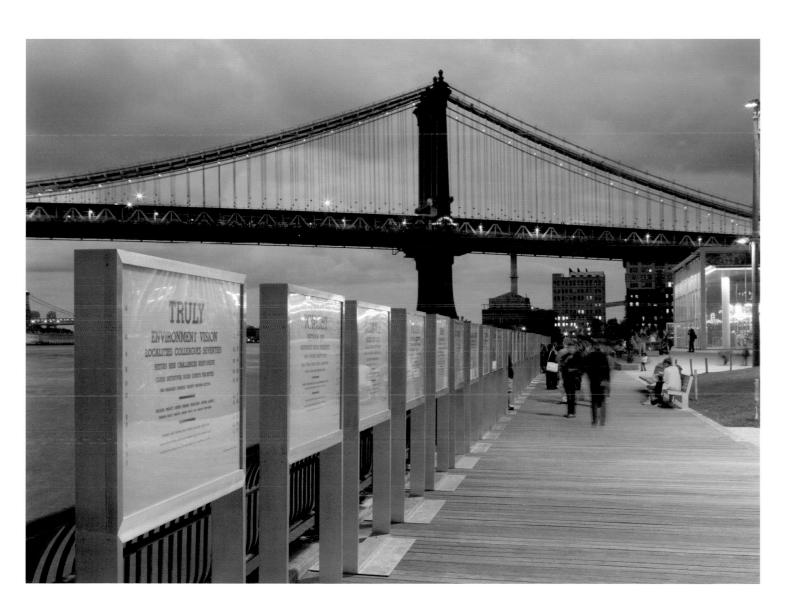

US

1980'S SECTOR

ENSURE AFGHANISTAN IRAN

WE'VE REGULATORY GLOBAL GULF

FUNDING CONTINUES PERSIAN SOLAR ADMINISTRATIONS

ISRAEL MINORITY PROLIFERATION SALT REFUGEES CAPABILITY

━━━━━━

ARTS FUELS KEY SOUTHWEST YOUTH GRAIN REFUGEE

EXPANDED RAPID HUMANITIES CHILD DEREGULATION DEPENDENCE QUICKLY RAIL

━━━━━━

PAPERWORK CAPABILITIES INVASION INTELLIGENCE IMPLEMENTATION SUPPORTED ABUSE I'VE FACED

ELDERLY REDUCING TECHNOLOGICAL EGYPT THREATS FOCUS INITIATED DISABLED HEALTHY

DISADVANTAGED RESTRAINT CLOSELY PATH LAUNCHED HAZARDOUS CARIBBEAN SOLVE TOP GROWN LEVELS

JAMES EARL CARTER, JR. / 1977-1981

Left column (top to bottom): $\frac{20}{200}$, $\frac{20}{100}$, $\frac{20}{70}$, $\frac{20}{50}$, $\frac{20}{40}$, $\frac{20}{30}$, $\frac{20}{25}$, $\frac{20}{20}$, $\frac{20}{15}$, $\frac{20}{13}$, $\frac{20}{10}$

Right column (top to bottom): $\frac{200\ \text{FT}}{61\ \text{M}}$ 1, $\frac{100\ \text{FT}}{30.5\ \text{M}}$ 2, $\frac{70\ \text{FT}}{21.3\ \text{M}}$ 3, $\frac{50\ \text{FT}}{15.2\ \text{M}}$ 4, $\frac{40\ \text{FT}}{12.2\ \text{M}}$ 5, $\frac{30\ \text{FT}}{9.14\ \text{M}}$ 6, $\frac{25\ \text{FT}}{7.62\ \text{M}}$ 7, $\frac{20\ \text{FT}}{6.10\ \text{M}}$ 8, $\frac{15\ \text{FT}}{4.57\ \text{M}}$ 9, $\frac{13\ \text{FT}}{3.96\ \text{M}}$ 10, $\frac{10\ \text{FT}}{3.05\ \text{M}}$ 11

DEFICITS

LET'S BLESS

DREAMS VETO EXCELLENCE

NEEDY PARENTS HONORED VICTIMS

DEPENDENCY LEADER LOVE STOP HEARTS

STARTED SOVIETS HEROES ENACT SAFER DESTINY

▬▬▬▬▬▬

SIMPLE ASKING WOMAN STRATEGY BREAK DRUGS PRESS

FRANKLIN TAKES ONE'S OLDER SETTING CLASSROOMS ILLNESS EIGHTIES

▬▬▬▬▬▬

UNBORN UNDERSTAND SAYING PERCENTAGE WON'T ENGINE CUTS CHURCH RESTORING

PARTNERS NIGHT TALK GUIDED POLITICS TEACHERS BELONGS COMPASSION GOVERNORS ITEM

PAYING ABORTION SUN FINISHED FIGHTERS MUSIC SANDINISTAS ROOSEVELT PAGES UNDERWAY NEGOTIATING

RONALD WILSON REAGAN / 1981-1989

Left scale (top to bottom):
20/200, 20/100, 20/70, 20/50, 20/40, 20/30, 20/25, 20/20, 20/15, 20/13, 20/10

Right scale (top to bottom):
1 — 200 FT. / 61 M
2 — 100 FT. / 30.5 M
3 — 70 FT. / 21.3 M
4 — 50 FT. / 15.2 M
5 — 40 FT. / 12.2 M
6 — 30 FT. / 9.14 M
7 — 25 FT. / 7.62 M
8 — 20 FT. / 6.10 M
9 — 15 FT. / 4.57 M
10 — 13 FT. / 3.96 M
11 — 10 FT. / 3.05 M

21ST

GOT LOT

COVERAGE AGREE AFFORDABLE

GUN ELSE FINISH LOWEST

LOSE CHILDREN'S CAMPAIGN BAN INTERNET

DOESN'T LADY CAME PLEASE NEIGHBORHOODS IMMIGRANTS

━━━━━━━━

VIOLENT BRADY EVERYBODY THANKS AMERICORPS INVESTMENTS LIFETIME

CRIMINALS BUY PARENT COVENANT MILLENNIUM CHOICES REPUBLICANS DEMOCRATS

━━━━━━━━

NUMBERS SICK CHEMICAL TEACH SMALLER READ PREPARE GUARANTEE RISK

HARDER SAVING ILLEGAL GRADE SUMMER RAISING CLASSROOM TERRORISTS BOSNIA RELIGIOUS

HIRE TOLD USING LIFT SHE'S SUPPORTING SENIORS WALK RICHARD COVER SCIENTISTS

WILLIAM JEFFERSON CLINTON / 1993-2001

Left column (top to bottom): 20/200, 20/100, 20/70, 20/50, 20/40, 20/30, 20/25, 20/20, 20/15, 20/13, 20/10

Right column (top to bottom):
200 FT. / 61 M — 1
100 FT. / 30.5 M — 2
70 FT. / 21.3 M — 3
50 FT. / 15.2 M — 4
40 FT. / 12.2 M — 5
30 FT. / 9.14 M — 6
25 FT. / 7.62 M — 7
20 FT. / 6.10 M — 8
15 FT. / 4.57 M — 9
13 FT. / 3.96 M — 10
10 FT. / 3.05 M — 11

TERROR
IRAQ IRAQI
TERRORIST AL QAIDA
REGIME HUSSEIN MASS HOMELAND
MARRIAGE COALITION ACCOUNTS 11TH MEDICINE
PRESCRIPTION REGIMES IRAQIS MATH INSPECTORS MURDER

———

HOPEFUL LEADING PAYS TECHNOLOGIES YOUNGER CAMPS TERRORISM
CULTURE ATTACKS GRATEFUL EXTREMISTS DOCTORS PRISON PROTECTING IRAQS

———

EMPOWER READING PATIENTS FRIVOLOUS LAWSUITS CONFRONTING CHENEY ALTERNATIVE DESTROYED

DIOLOGICAL DELIVER DISEASES BORDERS DEPENDENT KILL KILLED TRAIN SENIOR ADDICTION

BRINGS KILLERS DENY DEFEAT TYRANNY COMMANDERS DISARM RETREAT CHANGING SAYS UNPRECEDENTED

Left	Right	No.
20/200	200 FT / 61 M	1
20/100	100 FT / 30.5 M	2
20/70	70 FT / 21.3 M	3
20/50	50 FT / 15.2 M	4
20/40	40 FT / 12.2 M	5
20/30	30 FT / 9.14 M	6
20/25	25 FT / 7.62 M	7
20/20	20 FT / 6.10 M	8
20/15	15 FT / 4.57 M	9
20/13	13 FT / 3.96 M	10
20/10	10 FT / 3.05 M	11

GEORGE WALKER BUSH / 2001-2009

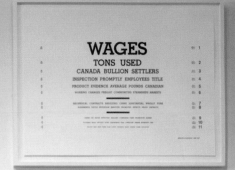
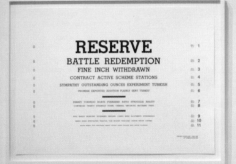
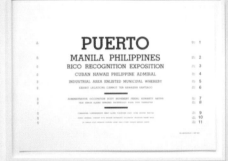
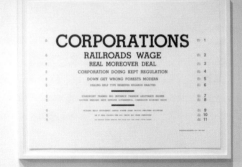
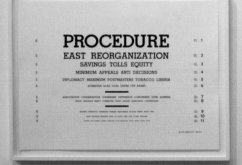
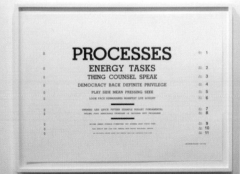

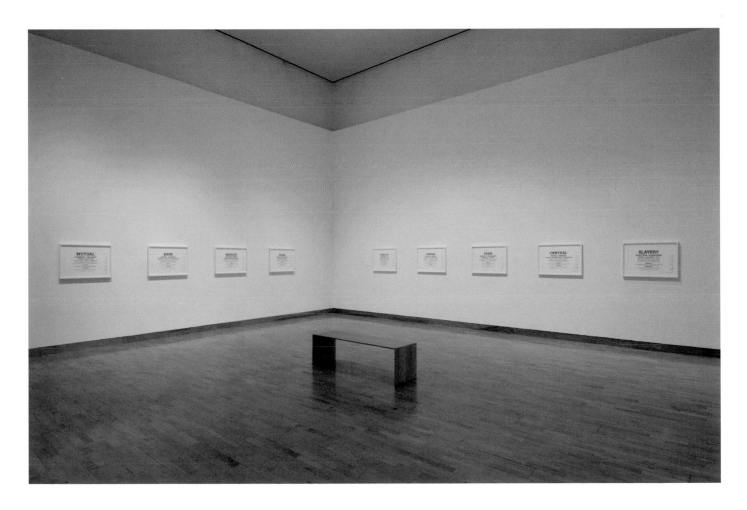

Hindsight Is Always 20/20, 2008 (installation, The Weisman Art Museum, University of Minnesota, Twin Cities, 2008).

Fashionably Late for the Relationship

Performance and film with Lián Amaris Sifuentes

2007–08

Fashionably Late for the Relationship is feature-length film created
from the documentation of a seventy-two-hour performance that took place
in Union Square in the summer of 2007. The piece is a collaboration with
performance artist Lián Amaris Sifuentes, who spent three days in a boudoir
on a traffic island preparing for a night on the town in slow motion and in
full public view.

I directed a thirty-person film crew over the three days, panoptically
documenting her performance using four high-definition video cameras.
The documentation was then accelerated to sixty speed and edited into a
seventy-two-minute film, using a combination of custom video blending
software and commercial editing tools. I then composed an accompanying
score in collaboration with violinist Todd Reynolds.

In the film, each of Sifuentes' actions, which took an hour in actual
time, translates into a minute of the film, resulting in a strange effect
by which she seems to be moving at an exaggerated, albeit normal, pace
while the entire city flies by around her. The piece was filmed and edited
according to a shooting script that meditates on different situations and
viewpoints in obsessive love, making the resulting two-part work a comment
on romance, gender relations, temporality, and public and private gaze.

Sifuentes' performance was open to the public, and the project received
front-page coverage in the *New York Times*. The film premiered at the 2008 01
Festival in San Jose, California.

online note, written 2010

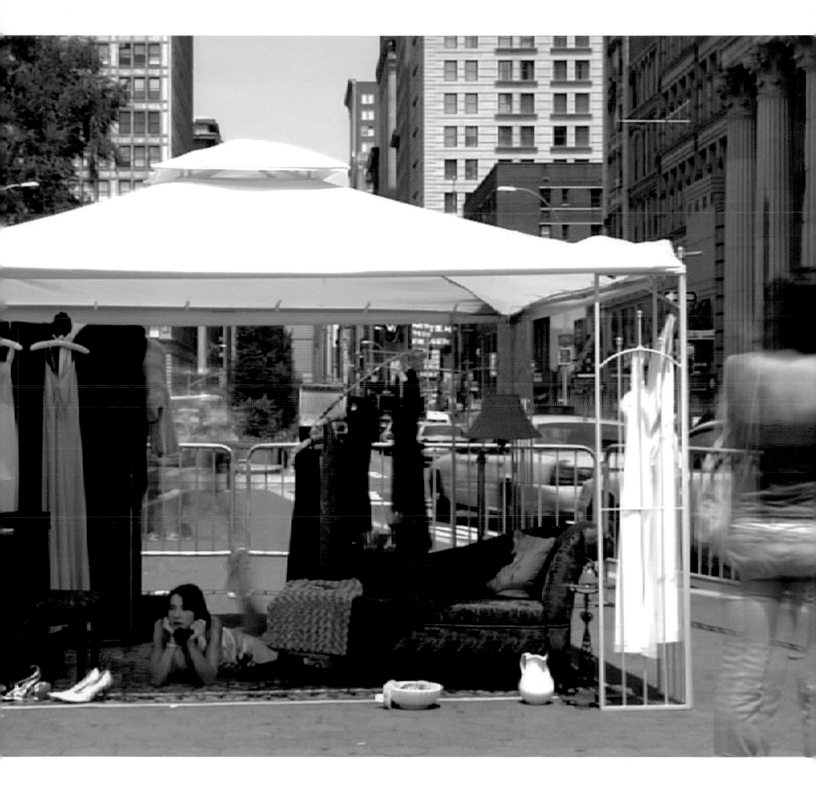

Fashionably Late for the Relationship

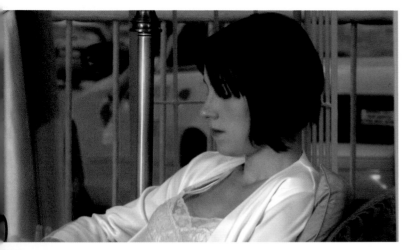
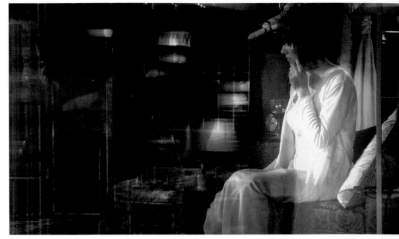
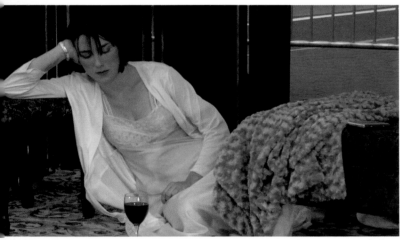

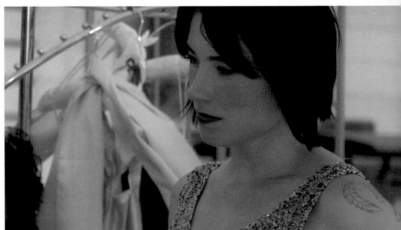

R. Luke Dubois — Now

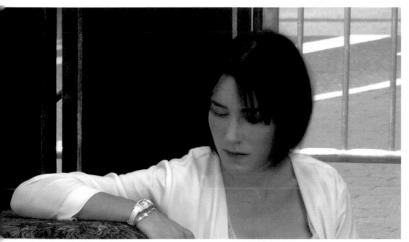
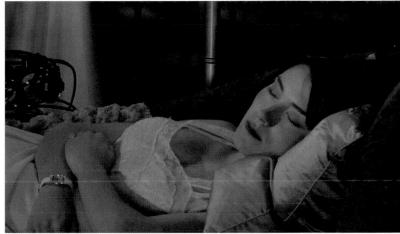
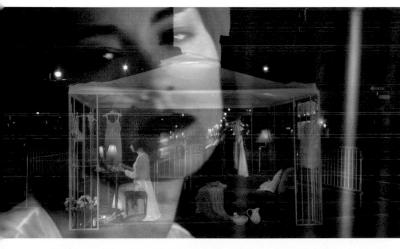
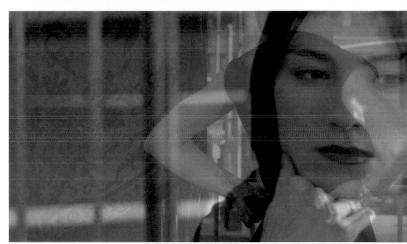
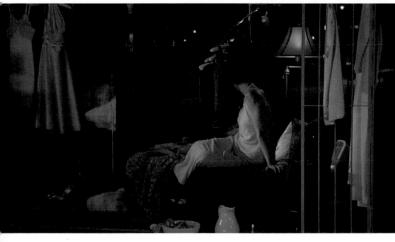
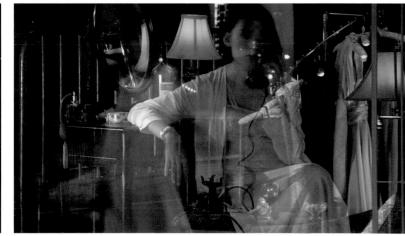

Fashionably Late for the Relationship 119

The Academy of Motion Picture Arts and Sciences began
hosting awards ceremonies (the "Oscars") in 1927. The
award for best picture evolved over the first three years
into an annual distinction that is unparalleled in the
film industry. *Academy* allows us to explore the temporal,
formal, and aesthetic progression of the first seventy-
five years of the Academy Awards by compressing the
sound and picture of each film into a single minute. The
piece also attempts to interrogate issues of film canon
by presenting the best picture winners in chronological
order in a massively condensed timeframe. Using frame
averaging and time-lapse phonography, the entirety of
each film is presented in a highly abbreviated snapshot.
Repeat viewing of the entire piece allows the viewer to
see not only cinematic history unfolding, but also formal
tropes in cinematography, editing, and music direction,
all of which are exposed through the massive acceleration
of temporal scale. The work, which was shown at the 2007
Sundance Film Festival, presents American cinematic
history as a time-lapse film, jogging our cultural memory
while giving into the attention deficiency of modern
media.

- - - - -

liner note, written 2006

Play

Video (50 seconds) in custom frame

2005

3.4.2007

Anamaria E. Cashman
Assistant Counsel
Playboy Enterprises, Inc.
680 N. Lake Shore Drive
Chicago, IL 60611

Dear Ms. Cashman,

My name is R. Luke DuBois and I am the artist
who created the work *Play*, a work created by
centering the eyes of women featured in Playboy
magazine. Steve Sacks, the gallerist who
represents my work at bitforms gallery in New
York City, has informed me that Hugh Hefner and
others at Playboy Enterprises are unhappy with
the work, their impression being that the piece
is little more than a sequence of images to which
Playboy owns copyright. I ask you to read this
letter and allow me to explain the piece in a bit
more detail as well as provide some insight into
what I feel, as an artist, the work represents so
that you will have a clearer picture of my motives
in creating the piece. It is my sincere hope that
after reading this Playboy Enterprises may have
an interest in ensuring that the piece remains
available for exhibition.

My background is not as a traditional
studio artist, but as a composer. I spent ten
years studying music composition at Columbia
University, completing my doctorate in 2003.
During this time I have worked extensively with
music and multimedia with a particular emphasis
on performance, and I've since taught at a
number of institutions, including Columbia, the
School of Visual Arts, and New York University;
I am currently a visiting lecturer at Princeton
University, where I am the guest director of
the Princeton Laptop Orchestra. In addition
to my work with music and video I am a software
developer, primarily working for San Francisco-
based software firm Cycling'74 and for artists
and musicians in and around the New York area.

In 2004 I began work on a series of pieces
that explore what I term the American cultural
canon; that is, the bodies of work (music, film,
photography, etc.) that, when taken as a corpus
of media, are an indispensable part of American
culture. The artistic challenge was to take these
different canons (which I will describe shortly)
and subject them to a computational process
that allows the viewer to experience the entire
body of work in totality in a reasonable viewing
time in order that s/he may discern a historical
progression, or patterns of repetition, or
cultural themes that may escape notice when the
individual works in the canon are looked at or
listened to separately. In addition, the pieces
are, importantly, about jogging the cultural
memory of those who experience them, allowing
us to revisit our lives through the significant
cultural artifacts that surround us.

The first piece I completed was called
Billboard; simply put, I took each song that
reached the #1 position on the Billboard Hot 100
chart since 1958 and subjected it to a radical
form of time-compression that left behind a
musical tone lasting for one second for every
week that song remained at #1. I then sequenced
the tones, creating a 37-minute sound work that
allowed the listener to experience the entire
history of the American pop chart in a brief
amount of time. The aim was to take an established
cultural canon (the hit record) and present it
in a way that allows us to hear how pop music has
changed over the years without listening to all
of the songs in sequence (a six day process). A

video serves to identify the songs as the piece progresses, giving us a chance to remember the parts of the chart through which we lived.

Another piece in the series, *Academy*, performs essentially the same task with the first 75 years of the Academy Awards, compressing each Best Picture into a single minute by averaging all of the frames into a moving average of the original film. Sequenced together, this 76-minute video work allows the viewer to see how cinema has evolved over the last century, progressing from the static shot language of early black-and-white Hollywood through the complex staging of Technicolor into the contemporary realm of fast-paced highly accelerated storytelling and special effects. As with *Billboard*, this was an attempt to demonstrate something about an important part of our culture in a way that viewing the films in sequence (a *ten* day process) would not.

Play was conceptualized as a complement to these two works, dealing with the cultural canon of female beauty through what I would argue is one of the most authoritative bodies of work on the subject: Playboy Magazine. Each Playmate of the Month's centerfold image from the first fifty years of the magazine's history (601 images in all) was digitized and subjected to a computer algorithm I designed that identified the face of the woman in the image; the computer then scaled, rotated, and cropped out only the face, centering each woman's eyes in the center of the frame. These images were then sequenced into a 50-second film at twelve frames, or a year of cultural time, per second. As a result, you see how the understanding of female beauty embodied in Playboy magazine, but in fact prevalent throughout our culture, progresses from the 1950s to the present.

The artistic decision to use images from Playboy Magazine, as opposed to another publication or source, was quite conscious on my part. The women featured as Playmates of the Month are, generally, not celebrities when they are photographed, nor are they selected based on their ability to act in films, perform music, or model designer clothing. They are simply women who the editors at your magazine feel are beautiful. Yet, for reasons that are both very simple and extremely complex, the women in Playboy serve as a fairly accurate template for what we as Americans understand to be beautiful as well, and this has been true at any point in the magazine's history. This is, obviously, both the reason for and a result of Playboy's success, and I have never found a need when discussing the work to describe Playboy's impact on American culture and our understanding of female beauty; it is self-evident to anyone, even if they've never bought a single issue of the magazine. For this reason I felt that the Playboy centerfold was the perfect subject matter to use as a way to *evoke* our understanding of beauty: as with the Billboard Hot 100 and the Academy Award for Best Picture, the Playmate of the Month is an undisputedly canonic part of American society. In its final form, *Play* is a work that delivers a meta-image that confirms Playboy Magazine's role in the curation of beauty in our culture.

As a work of art, *Play* is exhibited in a liquid-crystal display housed in an Art Deco-style picture frame hung from a wall at eye height. The 50-second film loops endlessly, and the individual images of the women quickly fuse, so that individual women are seldom recognizable unless, as often happens, the viewer has encountered them before. The eyes provide a focal point for the work, projecting a gaze that

easily meets the viewer and draws her/him in to the piece. We've exhibited the work several times and, and I've been met with unbelievably strong reactions, ranging from "devastating" to "impossible to walk away from" to "incredibly provocative." Viewers have taken away from the work a wide variety of impressions and memories, and the piece has brought a number of people to tears, including the woman with heartbreakingly beautiful eyes who served as my inspiration for the piece in the first place.

In addition to its modest exhibition record, I have screened *Play* to audiences during artist talks at various academic and cultural institutions, including Yale, Columbia, and Princeton Universities, Parson's School of Design, NYU, the University of California, Santa Barbara, the Walker Arts Center and, most recently, at the 2007 Sundance Film Festival. In the framework of academic discussion, it has sparked conversations about topics as diverse as idealized female beauty, platonic forms (our heads, as it so happens, are seven eye-widths tall and five wide, an important thing to know when designing an algorithm to center eyes), the historical progression of body image, the male gaze, the feminist response to the male gaze, computer vision, and the gestalt psychology of facial recognition. All of these discussions have been incredibly informative, and I sincerely feel the piece is above all else an excellent tool for facilitating discussion about the role beauty plays in our culture.

Having said all of this, I'd like to ask you to view the piece again, this time from a digital file of reasonable quality, rather than from the viewpoint of a work sample videotape of an exhibit. I've created a temporary website containing a QuickTime video of the piece here:

http://lukedubois.com/gallery/play.html

I've worked quite hard to treat the constituent images as the valuable works of photography that they are, and I feel that this piece does an excellent job of unfolding the historical progression of beauty and your magazine's role in that story since Marilyn Monroe was photographed in 1953. I hope you'll find that it's in your interest to keep the piece in exhibition, as it demonstrates not only something very interesting about our culture, but also that beauty is much larger than a sequence of pretty faces, something that I think your magazine understands quite well.

Feel free to contact Steve or myself if you have any questions or comments.

Thank you for your time.

Dr. R. Luke DuBois
Computer Music Center
Columbia University in the City of New York

Billboard

iPod with 37-minute sound work

2005

The Billboard Hot 100 chart launched on August 4th, 1958 as an attempt to consolidate a variety of sales and radio airplay charts into a single pan-genre listing that could serve as a standard metric of success in popular music. The Hot 100 has been computed using a number of methodologies over the years, initially based on a combination of singles sales in target record stores and airplay on a number of commercial radio stations chosen by Billboard on a rotating basis. This resulted in the Hot 100 being a fairly ephemeral metric of popular success, with new singles reaching #1 on a regular (almost weekly basis). Because of its reliance on radio play and single sales in key markets, it was also susceptible to manipulation, either by manipulating disc jockey behavior (the payola scandal of 1959) or by inflating single sales at a record store known to be counted in Billboard rankings.

Since 1991, the chart has been computed by Nielsen based on their SoundScan sales-tracking technology. As of 1998, it is no longer necessary for a formal 'single' to be commercially available in order to qualify for charting; record labels can choose instead to release an 'airplay-only' single, allowing sales of the entire album to improve the chart status of a single song. The result of these two major shifts has been for record labels to use Billboard tactically, waiting to officially release a 'single' until several cuts of a record are in rotation on radio stations and in music television markets; this results in far fewer songs acheiving #1 status per year (e.g. 9 in 1996 versus 35 in 1975.

Billboard allows you to get a birds-eye view of the Billboard Hot 100 by listening to all the #1 singles from 1958 through the millennium using a technique I've been working on for a couple of years called time-lapse phonography. The 857 songs used to make the piece are analyzed digitally and a spectral average is then derived from the entire song. Just as a long camera exposure will fuse motion into a single image, spectral averaging allows us to look at the average sonority of a piece of music, however long, giving a sort of average timbre of a piece. This gives us a sense of the average key and register of the song, as well as some clues about the production values present at the time the

record was made; for example, the improvements in home stereo equipment over the past fifty years, as well as the gradual replacement of (relatively low-fidelity) AM radio with FM broadcasting has had an impact on how records are mixed... drums and bass lines gradually become louder as you approach the present, increasing the amount of spectral noise and low tones in our averages.

The spectral average of each song used in *Billboard* plays for one second for each week it stayed at #1 on the Billboard Hot 100. Thus we run about 52 seconds per year, for a grand total of a 37-minute sound work. The video image tells you what song was used to generate the current spectral average. Note that nothing of the original recording is used in this piece; everything that you hear is derived from a statistical algorithm applied to the original recordings. If you know the song used in the average, you may be able to sing the first few bars (or the main hook in the chorus) over the spectral average and find that you are quite in tune with it; in some cases, you may be surprised not to be.

I feel that *Billboard* has an ancillary purpose of jogging our musical memory (or, for those of us who weren't alive when some of these songs were on the charts, jogging our expectations of popular music history). Many of what we consider seminal songs in pop history barely touched the charts: The Beatles' All You Need is Love spent only one week at #1 in 1967; the big hit that year was Lu Lu's To Sir With Love (5 weeks at #1). Similarly, many of what we consider to be important figures in late 20th-century popular music never charted. Many of them never released singles (e.g. Bob Dylan) or never courted commercial radio-play (e.g. Led Zeppelin, REM, Metallica, Nirvana). Most were simply never integrated into the mainstream commercial marketing system necessary for chart success, despite having huge followings and album sales; artists as diverse as Public Enemy and 10,000 Maniacs, both 'multi-platinum' groups, fall into this category.

While all of this may sound like a standard lesson in the fickleness of popular music, it's attractive to think that all of this has an effect on the 'sound' of a #1 hit. If there is such a thing as a 'hit sound' (as many a record producer and A&R executive has claimed, from George Martin to Ahmet Ertegun to Russell Simmons), perhaps we could hear it change from year to year.

Enjoy.

liner note, written 2005

Performances

LOSTWAX: Blinking, Particular

Evening-length works for dance and multimedia
2010–12

Blinking and *Particular* are two large-scale
works done in collaboration with LOSTWAX
Multimedia Dance and their choreographer,
Jamie Jewett. Both are evening-length dance
works that use video projections, computer
vision, and robotic lighting armatures to
create a performance space in which the dancers
are amplified and embodied through projected
light. *Blinking* uses as an artistic conceit
the investigation of what happens in the split
second when your eyes are closed while blinking.
Particular looks at "particularity" as both
a notion in science and in society, exploring
starling murmurations, particle physics, and the
nature of individual performers in an ensemble.
In both works, I wrote the music, served as
a production designer alongside Jewett, and
developed an elaborate software show-control/
media playback engine to run the video, lighting,
and sound elements of the piece. Central to the
staging in both works is a pair of projectors—
which are mounted on robotic pan-tilt lighting
armatures—that allow for the use of video as a
stand-in for normal theatrical lighting. They
permit me to program audio-visual reactive
systems that illuminate the performers' bodies
responsively, based on their motion, position
on stage, and what is happening in the music and
choreography at that time.

liner note, written 2013

(((PHONATION)))

Performance project with Bora Yoon
2008–present

Bora Yoon and I have been performing together in
a live show based on her recording
(((PHONATION))) since 2008. My focus in the
project is to act as a live visualist for her
multifaceted instrumental performance, much
of which involves the use and manipulation of
small sonic objects, such as music boxes, toy
phonographs, wind chimes, and metronomes. Those
pieces are sonically integral to Bora's set, but
their miniature scale is sonically exploded in
her work, as they form the basis of interlocking

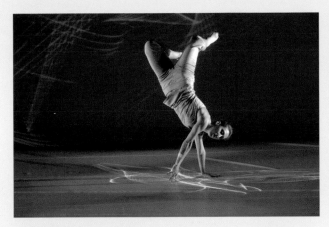

LOSTWAX: Particular, 2012.

Bora Yoon, *(((PHONATION)))*, 2010.

LOSTWAX: Blinking, 2011.

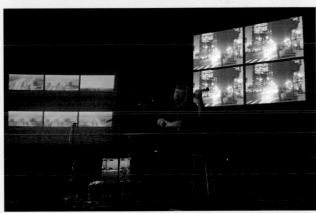

Todd Reynolds, *Still Life With Microphone*, 2007.

Bioluminescence, 2009.

Fair Use, 2010.

loops and layers upon which she sings and plays viola, piano, or guitar. The challenge in the performance is to create a visual canvas of projection using only live camera feeds and video delays that allow me to capture her small gestures and amplify them as a visual backdrop, at once elucidating and expanding upon those small, intimate musical gestures so that their image scales to their sound.

artist note, written 2011

Still Life With Microphone

Performance project with Todd Reynolds
2005–present

Todd Reynolds's one-man revue show, *Still Life With Microphone*, is part theater, part improvised set, and part chamber concert, bringing Todd's incredible stagecraft and personality to life as he performs his own, often improvised, work alongside commissioned repertoire from other composers. For Todd, I have created a series of synaesthetic projection mappings that generate animations or process footage live while he plays, often blending in live camera work during the show. We sometimes use multiple screens, allowing me to show footage, animations, and cameras all at once, providing multiple visual access points to the sonic textures that Todd creates with his violin and laptop computer.

artist note, written 2008

Bioluminescence

Performance project with Lesley Flanigan
2006–present

I have been performing since 2006 in a duet with vocalist Lesley Flanigan. The project, dubbed *Bioluminescence*, consists of a performance between Flanigan and myself. Meditating on the female voice, the project consists of improvisations between the live singer and a bank of samples captured in situ during the performance, which can be transposed, re-arranged, and stretched by myself at the computer. Real-time visualizations of the sound are projected overhead. Our artist statement, in part reads:

The voice has a unique role in our musical culture, bridging the linguistic and the semiotic in a way that transcends instrumentality through a highly personal embodiment of musicianship. The recorded female voice, in particular, has been the subject of academic investigation following its role in aesthetics (Adorno), cinema and psychology (Silverman), and feminist theory (De Laurentis). In electroacoustic music, the voice has a privileged place in our canon, providing a boundless source of material for sonic exploration from the tape works of Berio, Dodge, and Lansky through the composer-performer repertoires of Joan LaBarbera and Pamela Z. Our collaboration centers around an extensive investigation of the possibilities of the improvised voice in tandem with electroacoustic processing, focusing on the possibilities of detemporalization and memory evoked through the use of looping, time-stretching, and spectral processing. The interplay between the two performers (one singing, one processing) takes the metaphor of the voice as impulse and the computer as filter and creates a dense palette

of evocative sounds and images derived entirely from the voice of the singer.

The project runs on custom software that I've written that allows me to use the laptop as a live sampler to capture Flanigan's voice into "banks" of four short phrases each, which can be triggered in any sequence at variable speed and pitch, entirely by typing on the computer keyboard. In performance, this allows us to perform entire pieces while maintaining eye contact, creating the illusion of an intimate conversation between two people.

artist note, written 2008

Fair Use

Performance project with
Matthew Ostrowski and Zach Layton
2005–present

Fair Use is a performance project I started in 2005 with two fellow avant-garde electronic performers: Matthew Ostrowski and Zach Layton. The project is essentially a film screening (often a double- or triple-feature) that shows cinema not as we see it in a movie theater but as we remember it later. The performance, therefore, remixes cinema as an act of memory, allowing a two-hour film to be presented in a matter of tens of minutes, as most of it flies by in a blur, with only a few key moments lingering. The performance divides the musical labor according to the stem mixes of film sound, with snippets of film dialog generated by me, "Foley" and other sound effects treated, stretched, and performed by Ostrowski, and the musical score remixed and performed by Layton. The film is played at a nominal speed of ten times its normal pacing, with key moments paused, scrubbed, and revisited, with visual effects layered on top that add to the metaphor of remixing time and memory.

During a typical live performance, *Fair Use* will present Hollywood classics such as *The Wizard of Oz* and *Casablanca*, animated films such as *Snow White and the Seven Dwarfs*, action movies such as *Top Gun*, and science fiction classics such as *Blade Runner* and *2001: A Space Odyssey*. The title of the project is a comment on the copyright provision that allows for this type of derivative work.

artist note for transmediale, 2010

Earlier Work

Synaesthetic Objects

Audio-visual performances and installations
2000–07

From 2000 to 2007 I worked on a series of
performances and installations called
Synaesthetic Objects. Originally developed
for the 2000 Lincoln Center Festival, the body
of work flourished through collaborations
with video artists (including Mark McNamara),
musicians (such as ETHEL), and choreographers
(Christina Towle and Beliz Demircioglu) through
multiple iterations. The conceit of the pieces
was to create an audiovisual experience in which
a simple intermediary algorithm was employed
to translate sound into image, or vice versa,
in an engaging and direct manner.

Soundscape Navigator, the first of the series,
was developed as a piece with Mark McNamara. The
work allowed for the participatory performance
of looped sonograms in an installation context.
The user was presented with a joystick and four
buttons by which she or he could "scrub" sonograms
in two dimensions, changing their speed and pitch
independently. A performance version—which was
developed during a residency at STEIM in 2000

with choreographer Christina Towle—translated
the system as an audio-visual backdrop for
camera-tracked dance.

Further live performance versions of the
work explored the use of generative video as an
amplification scheme for media performance.
In 2004, a second iteration (called *Birds*) was
developed with New York-based string quartet
ETHEL during a residency at the Massachusetts
Museum of Contemporary Art. That version
visualized the string quartet as a flock of
origami-like shapes that could fold and spiral
around one another in response to the spectral
input and rhythms of the players. It was used
as a visual avatar-like presence for their
performance repertoire during the residency.

In 2005-06, a second dance-related
iteration of the work was created with Turkish
choreographer Beliz Demircioglu. It was
developed as a project for the NIME conference
in Vancouver, Canada, as well as a modern dance
festival in Pisa, Italy. *Polar* used a vertically
mounted camera to visually embellish and sonify
the actions of a solo performer on a large
turntable; drawing from mandala, circular

Synaesthetic Objects: Coltrane, 2008.

Repeat After Me, 2003.

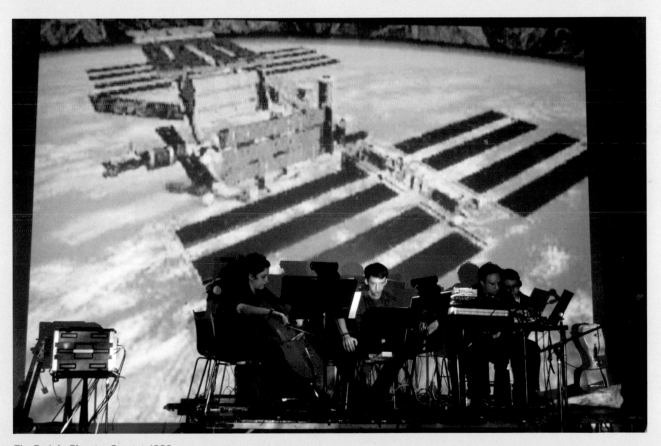

The Freight Elevator Quartet, 1999.

schematizations of Western harmony (for example, the cycle of fifths), and Wheel of Fortune, the performance enabled a solo dancer to generate a wide array of audiovisual material.

As a solo performer, I have been using a laptop version of the software (*Coltrane*), which uses OpenGL computer graphics to create complex, generative shapes based on acoustic and musical analyses of John Coltrane's 1966 masterpiece, *Ascension*. The work develops figurative, abstract, and constantly shifting geometries that are then rescanned to create a direct acoustic result. What you see and hear has the energy and improvisational complexity of the source material, translated into an ever-shifting virtual architecture with an accompanying musical drone.

Applications of Generative String Substitution Systems in Computer Music
DMA dissertation, Columbia University
2003

The purpose of this dissertation is to create and explore potential taxonomies for using algorithmic string-substitution systems in the generation of music. The focus of the author's research is on using a specific category of string rewriting systems (called Lindenmayer, or L-systems) to generate musical material based on a musical primer provided by a live musician or musicians. The author explores and describes a variety of possible composing methodologies whereby a computer can generate, in real time, appropriate accompanying music and signal processing to a live performer. By experimenting with different taxonomies of mapping source material (live musical input) to accompanying processes (provided by the computer), an

extensive system for generating a varied, yet systematically cohesive, corpus of musical work can be achieved. A series of short compositions based on this string-substitution process are included as applications of this system.

The Freight Elevator Quartet
R. Luke DuBois, Paul Feuer, Rachael Finn, and Stephen Kreiger
1996–2003

From 1996 to 2003, I had a band called the Freight Elevator Quartet that performed improvised electronic music. We released three studio recordings (including one in collaboration with DJ Spooky), two live albums, and two 12" dance singles (featuring remixes by A Guy Called Gerald, among others). Our original concept for the group was to create the musical version of Steampunk, a literary genre in which contemporary authors write science fiction from the vantage point of people in centuries past: "the present imagining the past imagining the future." As a result, our entire musical output was about sowing temporal and genre-related confusion by blending instruments and styles that, according to mainstream musical taste, had no business being in the same room.

Select Bibliography

Amaris, Lián. "Beauty and the Street: 72 Hours in Union Square, NYC." *TDR/The Drama Review* 52, no. 4 (winter 2008): 182–92.

Annas, Teresa. "A Clear Vision of Presidents' Messages." *The Virginian-Pilot*, January 17, 2009.

"Art in Denver: No Contest." *Art In America*, June/July 2008, 37.

Baca, Marie. "Silicon Valley Singles All about Queer, Decadent Robots in Online Dating Profiles." *Venture Beat*, March 31, 2011, http://venturebeat.com/2011/03/31/silicon-valley-singles-all-about-queer-decadent-robots-in-online-dating-profiles/.

Bazley, Lewis. "The Happiest State in the Union: Tennessee Residents Have the Most to Smile About (according to Twitter at least)." *The UK Daily Mail*, April 6, 2011.

Bennett, Bruce. "The Artist Hits Her Own Mark." *The Wall Street Journal*, December 8, 2010.

Bookhardt, Eric D. "Prospect.2: Canvassing the City." *The Gambit*, September 27, 2011.

Bryant, Anne. "Art Review: 'iImage,' beyond the Traditional Portrait." *Portsmouth Herald*, March 17, 2011.

Buzzell, Colby. "Red, White, and Beige: The State of the Union, 2008." *Esquire*, February 2008, 66.

Clendaniel, Morgan. "Infographic of the Day: How America Describes Itself in Dating Profiles." *Fast Co Design*, April 5, 2011, http://www.fastcodesign.com/1663556/infographic-of-the-day-how-america-describes-itself-in-dating-profiles.

Decter, Joshua. "R. Luke DuBois Review." *Artforum*, April 2011, 217–18.

Diaz, Eva. "Prospect.2, New Orleans." *Artforum* 50, no. 6 February 2012.

Donohue, Brian. "The Odd Mating Calls of New Jersey Lovebirds." *The Star-Ledger: Ledger Live* video, April 22, 2011, http://www.nj.com/ledgerlive/index.ssf/2011/04/the_odd_mating_calls_of_new_je.html.

Duray, Dan. "Prospect.2 Art Exhibition Reveals Highlights." *The New York Observer*, September, 20, 2011.

Gee, Robyn. "19 Million Profiles Later...Online Dating Lingo Tapped and Mapped." *Turnstyle*, April 5, 2011, http://turnstylenews.com/2011/04/05/19-million-profiles-later-online-dating-lingo-tapped-and-mapped/.

Golijan, Rosa. "Online Dating Maps Reveal Kinkiest and Loneliest Places." *Digital Life on TODAY*, April 5, 2011, http://www.today.com/tech/online-dating-maps-reveal-kinkiest-loneliest-places-124005.

Haldiman, Philip. "Public Artwork Focuses on State of the Union Addresses." *The Arizona Republic*, January 9, 2010.

Hayes, Cathy. "New Map Tracks Americans Looking for Love." *Irish Central*, April 8, 2011.

Heussner, Ki Mae. "Online Dating" Maps Show Where Happiest, Kinkiest People Live." *ABC News*, April 6, 2011, http://abcnews.go.com/Technology/online-dating-profiles-map-shows-happiest-kinkiest-americans/story?id=13310426#.UaykGkDqnTo.

Johnston, Garth. "New Yorkers Use Interesting Words When Dating Online." *Gothamist*, April 5, 2011, http://gothamist.com/2011/04/05/new_yorkers_have_interesting_word_c.php.

Kennedy, Lisa. "Politics Stokes Digital Artists' Fires." *Denver Post*, August 21, 2008.

MacCash, Doug. "Prospect.2 New Orleans, International Arts Exhibition, Opens Saturday." *The Times-Picayune*, October 21, 2011.

MacMillan, Kyle. "'Dialog:Denver' Reprises Theme." *Denver Post*, August 29, 2008.

Mathers, Ian. "R. Luke DuBois." *Stylus Magazine*, June 27, 2006, http://stylusmagazine.com/reviews/r-luke-dubois/timelapse.htm.

Miranda, Carolina A. "The Art of Online Dating." *WNYC Culture Blog*, January 24, 2011, http://www.wnyc.org/blogs/gallerina/2011/jan/24/art-online-dating/.

Molinsky, Eric. "A More Perfect Union." *Studio 360*, National Public Radio, April 8, 2011.

Morrissey, Aaron. "What the District Wants in a Soulmate." *DCist*, April 5, 2011, http://dcist.com/2011/04/what_the_district_wants_in_a_soulma.php.

Overturf, Madeleine. "Data-based Artwork Eases Analysis with Visual Representation." nyunews.com, April 3, 2013, http://nyunews.com/2013/04/03/data/.

Robertson, Campbell. "She's Got a Date and Only 72 Hours to Prepare." *The New York Times*, July 9, 2007.

Robertson, Campbell. "Time Runs Out on Date Night." *The New York Times*, July 11, 2007.

Rydberg, Erika. "The United States of Lonely, Crazy, or Sexy? An Infographic Census of Love." *All Things Considered*, National Public Radio, April 21, 2011.

St. John Erickson, Mark. "New Exhibit Gives Insight to Different Presidential Eras." *Daily Press*, January 18, 2009.

Skarda, Erin. "The Unofficial Singles Census: Mapping Our Online Dating Lingo." *TIME NewsFeed*, April 2011, http://newsfeed.time.com/2011/04/07/the-unofficial-singles-census-mapping-our-online-dating-lingo/.

Squibb, Stephen. "Hard Data and Hindsight: Interview with R. Luke DuBois." *Idiom*, August 5, 2010, http://idiommag.com/2010/08/hard-data-and-hindsight-interview-with-r-luke-dubois/.

Zeitvogel, Karin. "Website Maps What Americans Look for in Love." *American Free Press*, April 6, 2011.

Contributors

R. Luke DuBois is a composer, artist, and performer who explores the temporal, verbal, and visual structures of cultural and personal ephemera. He holds a doctorate in music composition from Columbia University, and has lectured and taught worldwide on interactive sound and video performance. He has collaborated on interactive performance, installation, and music production work with many artists and organizations including Toni Dove, Todd Reynolds, Jamie Jewett, Bora Yoon, Michael Joaquin Grey, Matthew Ritchie, Elliott Sharp, Michael Gordon, Maya Lin, Bang on a Can, Engine 27, Harvestworks, and LEMUR, and was the director of the Princeton Laptop Orchestra for its 2007 season.

Stemming from his investigations of "time-lapse phonography," his work is a sonic and encyclopedic relative to time-lapse photography. Just as a long camera exposure fuses motion into a single image, his projects reveal the average sonority, visual language, and vocabulary in music, film, text, or cultural information. Exhibitions of his work include: the Insitut Valencià d'Art Modern, Spain; 2008 Democratic National Convention, Denver; Weisman Art Museum, Minneapolis; San Jose Museum of Art; National Constitution Center, Philadelphia; Cleveland Museum of Contemporary Art; Daelim Contemporary Art Museum, Seoul; 2007 Sundance Film Festival; the Sydney Film Festival; the Smithsonian American Art Museum; and PROSPECT.2 New Orleans. His work and writing has appeared in print and online in the *New York Times*, *National Geographic*, and *Esquire* Magazine.

An active visual and musical collaborator, DuBois is the co-author of Jitter, a software suite for the real-time manipulation of matrix data developed by San Francisco-based software company Cycling'74. He appears on nearly twenty-five albums both individually and as part of the avant-garde electronic group The Freight Elevator Quartet. He currently performs as part of Bioluminescence, a duo with vocalist Lesley Flanigan that explores the modality of the human voice, and in Fair Use, a trio with Zach Layton and Matthew Ostrowski, that looks at our accelerating culture through electronic performance and remixing of cinema.

DuBois has lived for the last twenty years in New York City. He is the director of the Brooklyn Experimental Media Center at the Polytechnic Institute of NYU, and is on the Board of Directors of the ISSUE Project Room. His records are available on Caipirinha/Sire, Liquid Sky, C74, and Cantaloupe Music. His artwork is represented by bitforms gallery in New York City.

Anne Collins Goodyear, PhD, is Co-Director of the Bowdoin College Museum of Art and President of the College Art Association. Previously, she was Curator of Prints and Drawings at the National Portrait Gallery, Smithsonian Institution, and Professorial Lecturer in the Department of Art and Art History at the George Washington University. She is co-editor of *Inventing Marcel Duchamp: The Dynamics of Portraiture* (2009), *Analyzing Art and Aesthetics* (2013), and *aka Marcel Duchamp: Meditations on the Identities of an Artist* (forthcoming 2013). Goodyear has published extensively on modern and contemporary art and portraiture, with an emphasis on how recent developments in science and technology have shaped visual culture.

Matthew McLendon, PhD, is Curator of Modern and Contemporary Art at The John and Mable Ringling Museum of Art in Sarasota, Florida. While at The Ringling, he has overseen the permanent installation of *Joseph's Coat*, the Skyspace by renowned artist James Turrell. He has also curated numerous exhibitions, including *Beyond Bling: Voices of Hip-Hop in Art*, *Zimoun: Sculpting Sound*, and *Sanford Biggers: Codex*. Previously, McLendon was Curator of Academic Initiatives at the Cornell Fine Arts Museum, Rollins College. While completing his doctoral thesis at the Courtauld Institute of Art, he served as Interim Curator of Adult Learning at Tate Britain. McLendon is on faculty at Florida State University where he teaches graduate seminars in contemporary art and museum practice, and he is visiting faculty at New College of Florida, the State Honors College.

Dan Cameron is Chief Curator at the Orange County Museum of Art. From 2006 to 2011, he founded and directed Prospect New Orleans, an international biennial developed to bring art world attention to post-Katrina New Orleans. For most of that period, Cameron also served as Director of Visual Arts for the Contemporary Arts Center, New Orleans, where he organized the group exhibitions *Something from Nothing*, *Make-it-Right*, *Previously on Piety*, *Interplay*, *Then and Now*, *Patterns and Prototypes*, and *Hot Up Here*.

From 1995 to 2006, Cameron was Senior Curator at the New Museum in downtown Manhattan, where he organized numerous important group and solo exhibitions, including retrospectives of Carolee Schneemann, William Kentridge, Paul McCarthy, Doris Salcedo, Marcel Odenbach, Faith Ringgold, David Wojnarowicz, Carroll Dunham, Martin Wong, and Cildo Meireles.

Since 1982, Cameron has published hundreds of book, catalogue, and magazine texts on contemporary art.

Matthew Ritchie's installations integrating painting, wall drawings, light boxes, performance sculpture, and projections are investigations of the idea of information; explored through science, architecture, history, and the dynamics of culture, defined equally by their range and their lyrical visual language. In 2001, *Time* magazine listed Ritchie as one of 100 innovators for the new millennium, for exploring "the unthinkable or the not-yet-thought." His work has been shown in numerous exhibitions worldwide, including the Whitney Biennial, the Sydney Biennial, the Sao Paulo Bienal, the Venice Architecture Biennale, the Seville Biennale, and the Havana Biennale.

His work is in the collections of the Museum of Modern Art, the Guggenheim Museum, the Whitney Museum of American Art, the Albright Knox Museum, the San Francisco Museum of Modern Art, and numerous other institutions worldwide. Awards include the Baloise Art Prize, a National Association of Art Critics award, an ID design award, and the Federal Art In Architecture National Honor Award. He has written for *Artforum*, *Flash Art*, *Art & Text*, and the *Contemporary Arts Journal*, and is a contributor to *Edge*.

In 2012 he was Artist in Residence at the Getty Research Institute, Los Angeles, and is currently Mellon Artist in Residence and Adjunct Professor in the Graduate Visual Arts Program at Columbia University, New York.